2000

Collective Vision

Collective Vision

Creating a Contemporary Art Museum

Museum of Contemporary Art
Chicago

Collective Vision was published in conjunction with the opening of the Museum of Contemporary Art on July 2, 1996, in Chicago.

The Museum of Contemporary Art (MCA) is a non-profit tax-exempt organization. The MCA's exhibitions, programming, and operations are member supported and privately funded through contributions from individuals, corporations, and foundations. Additional support is provided through the Illinois Arts Council, a state agency, and American Airlines, the official airline of the Museum of Contemporary Art.

Lead corporate sponsors for the Museum of Contemporary Art's grand opening and inaugural year are American Airlines, Bank of America, Hal Riney & Partners, Marshall Field's and Target stores, Philip Morris Companies Inc., and the Sara Lee Corporation.

ISBN 0-933856-42-3 (cloth)
0-933856-43-1 (paper)

Published by the Museum of Contemporary Art, 220 East Chicago Avenue, Chicago, Illinois, 60611.
Distributed by The University of Chicago Press.

Produced by the Publications Department of the Museum of Contemporary Art, Chicago, Donald Bergh, Director, and Amy Teschner, Associate Director.

Publication Coordinator and Editor: Terry Ann R. Neff, t.a. neff associates, inc., Tucson, Arizona

Architecture photography by Steve Hall, © Hedrich Blessing, Chicago.

Printed and bound by Friesens in Altona, Manitoba, Canada.

Photography Credits
Photographs on pages ii, viii, 1, 25, 26 (bottom), 28 (top), 37–45, and 47 by Steve Hall, © Hedrich Blessing; on page 2 by Shunk-Kender, New York; on page 7 (top) by David Van Riper; on page 7 (bottom) by Jean-Claude LeJeune; on pages 13 and 15 by Tom Van Eynde; on page 17 (bottom) by Artur Starewicz; on pages 21 and 30 (top) by James Prinz; on pages 26 (top) and 46 by Hélène Binet; on page 30 (bottom) by Sackmann fotographie; page 32 by Jörg P. Anders, Staatliche Museen zu Berlin—Preussischer Kulturbesitz Kupferstichkabinett; and on page 34 © Hedrich Blessing. All other photographs © Museum of Contemporary Art, Chicago.

Contents

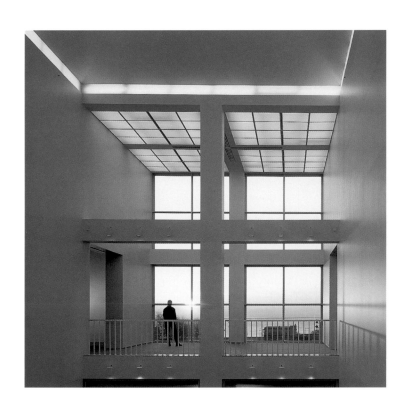

A Vision and a Legacy

In 1967 vision, courage, commitment, and hard work led to the founding of a new museum in Chicago, the Museum of Contemporary Art. In 1996 those same qualities have resulted in the museum's new building, an architectural landmark that allows the MCA to take its place among the great museums in the world.

These achievements have grown from the belief that the City of Chicago and the State of Illinois deserve a great contemporary art museum. We saw the need for a museum where people of all ages and backgrounds could experience and learn about contemporary art, a place with expansive facilities and innovative educational programs. We dreamed of a home for the masterpieces in Chicago's remarkable collections. We envisioned a forum where art by today's most thoughtful and gifted artists could illuminate the issues confronting our society.

That vision, coupled with a profound belief that art has the power to change lives for the better, formed the foundation for the MCA's plans for a new museum. Next came the courage to act on that vision. The museum we dreamed of would quintuple the present physical plant and triple its operating budget. Even after extensive economic analysis, a thorough assessment of market conditions, and prudent strategic and financial planning, the decision to proceed with the project was a brave one—which could not succeed with timid steps forward, but required bold and forceful action.

The commitment of the Museum of Contemporary Art's Board of Trustees to launch the project was just such a bold act. Under the leadership of trustee Jerome H. Stone, the museum initiated the Chicago Contemporary Campaign with the unprecedented sum of $37 million committed by its fifty board members. It has been a monumental achievement by any standard, even in a city like Chicago that is rich with civic accomplishments. Now having surpassed its $55 million goal on its way to $65 million, the Chicago Contemporary Campaign has received support from corporations, foundations, and individuals throughout the community who endorse our vision and confirm the pressing need for the project.

Ultimately, the new museum has been made possible by the inspired efforts of countless devoted, gifted individuals. Fueled by their shared passion for contemporary art, the MCA family has worked together tirelessly to ensure the museum's

future. Especially deserving of recognition are the esteemed men and women who preceded me as chairs of the Museum of Contemporary Art and who served on the Armory Planning Committee, where the new museum project began. Joseph Randall Shapiro, Edwin A. Bergman, Lewis Manilow, Helyn D. Goldenberg, John D. Cartland, and Paul Oliver-Hoffman each made peerless contributions toward the museum's success.

Also deserving of praise is the distinguished trustee group I had the privilege of leading in the quest to find an architect for the new museum. After a world-wide search and hours in deliberation, we chose Josef P. Kleihues of Berlin, who has confirmed our initial judgment with a brilliant addition to Chicago's architectural legacy.

"On time and on budget" is a phrase rarely applied to major construction, but the MCA's project has earned that distinction thanks to the diligence and expertise of J. Paul Beitler and his fellow trustees on the building and design review committee. The MCA has been most fortunate of all in the leadership of its director and chief executive officer, Kevin E. Consey. He has made the dream of a new museum a reality. His insight, intellect, leadership, energy, and ability sustained the project from concept to completion. Without Kevin Consey and the support of an outstanding staff of professionals, the new museum project would not have been possible.

From the Women's Board, to the volunteer guides, to the museum's supporters on the Contemporary Art Circle, heartfelt thanks are due to all of the people who nurtured, sustained, and made real our vision for a new museum.

As exciting as is this moment in the MCA's history, with a striking new building, innovative programs, and fresh ideas, I am most excited by the museum's future. As we look ahead to a new century, the MCA is poised to take a lead in the effort to make art more central to the life of our community.

Allen M. Turner
Chairman, Board of Trustees

Building for the Future

In any complex project, but perhaps especially building projects, one runs the risk of losing the forest for the trees. Whether you are building a summer cottage or a museum, tending to thousands of essential details—doorknobs, air ducts, materials, codes—can cause you to lose track of the real reason you are building in the first place. The hows can overwhelm the whys.

Thanks to a remarkable group of trustees, a dedicated staff, a generous and supportive community, and exceptionally talented consultants, how we built this new museum never became more important than why we were doing it. The solutions to the challenges we faced during the years of this project always supported our overarching goal: to create a new type of museum that would effectively and vividly present and preserve contemporary art. For a relatively young museum—the MCA was founded in 1967—this was a heady challenge and one that demanded considerable hard work and not a little nerve.

In 1984 the museum took stock of its history and accomplishments and began to chart a course toward the next millennium. The results of this analysis were sobering, indicating that the museum could not expect to continue to fulfill its mission in its facility at 237 East Ontario Street. The demands of the changing world of contemporary art, combined with the museum's rapidly expanding audience, were rendering the current building obsolete. Contemporary art exhibitions and even individual works of art were becoming too large to fit inside the museum's galleries. Only a fraction of the works in the MCA's extraordinary collection could be on public view at any time, restricting the interest of both the public and potential donors. The demand for educational programs was four to five times greater than the museum could provide. With options for expansion at its current address limited, the leadership of the museum began to look for a new home for the MCA.

The site of the Chicago Avenue Armory, where the Illinois National Guard had been quartered for approximately eighty years, is arguably one of the most magnificent building sites in the world. Overlooking Lake Michigan to the east and historic Water Tower to the west, bounded by two public parks in the heart of Chicago's most vital retail, business, and residential neighborhood, the site is ideally suited for a museum. Through an unprecedented private-public partnership, the MCA

was granted a ninety-nine-year-renewable lease on the property from the State of Illinois Department of Conservation (thereby becoming the first major Illinois state park in the City of Chicago). In exchange, the museum donated to the State Department of Military Affairs a significant parcel of land and building on Prairie Avenue that were readily converted into the new Chicago headquarters for the Illinois National Guard.

The Armory deal, structured in 1989, galvanized the planning efforts for the new museum with a daunting challenge. To live up to the extraordinary potential of the site, the new MCA had to become one of the foremost art museums in the world. Based on the MCA's rich and distinguished history, the staff and board set out to draft an artistic and educational blueprint for an expanded institution. The goal was to create a new international standard for what a contemporary art museum should and could be.

The time was right for a fresh examination of a contemporary art museum's role and potential. Museums throughout the nation and world were in a state of flux verging on crisis due to diminishing funding sources and rising expenses. Contemporary art itself was in a transitional state, rebounding from the economic boom and star system of the 1980s to a period with an unprecedented array of school's, styles, movements, and philosophies. Artists taking radical approaches to scale, mediums, and location were pressing the existing definitions and boundaries of contemporary art—and art museums—to the breaking point.

Coupled with these trends was the often uncomfortable dynamic of the shifting demographics of the city. It became harder to reach out to all segments of society, particularly those traditionally underserved by cultural resources. The elimination of art education from public school curriculums raised the likelihood that future generations would suffer from an absence of art in their lives.

In the light of these developments, it seemed clear that museums could no longer serve only as aesthetic and educational institutions, but had to become agents of social change as well. As a result, the Museum of Contemporary Art began to develop a new, expanded vision for the institution that addressed the questions these new challenges raised: What forms will con-

temporary art take in the future and how can a museum retain the flexibility necessary to accommodate them? How do people learn about art and what sorts of resources are needed to reach people of all ages and backgrounds? What role should a permanent collection play in a museum of contemporary art? How can the relationships between visual art and other art forms be successfully explored in a museum setting? How can the interplay between art created locally and elsewhere in the world best be portrayed?

As the artistic and educational vision for a new museum took shape, it was translated into an architectural program, a document that detailed the museum's space needs and technical requirements. The architectural program covered such topics as the use of natural and artificial light in gallery spaces, temperature and humidity needs for the protection and preservation of art, guidelines to ensure ease of public circulation, and specifications for a state-of-the-art educational theater. The program ensured that the MCA's new building would be designed from the inside out, with the activities and mission of the museum shaping the building rather than vice versa.

Simultaneously, a long-range strategic plan was developed to set the course for the fulfillment of the museum's mission, now revised and expanded. The plan set forth a financial structure intended to provide adequate funds not just for construction of the new facility, but also for a high standard of operations in perpetuity. An operating budget was developed to support a rich array of artistic and educational offerings, and an outreach program was put in place so that a broad and varied audience would benefit from the MCA's programs.

Central to the plan was a major fundraising effort called the Chicago Contemporary Campaign, launched in 1989. Fueled by the enthusiasm of corporations, foundations, and private individuals in Chicago and throughout the nation, the campaign in 1996 is on its way to exceeding its $55 million goal. With the Chicago Contemporary Campaign providing endowment and operating support for the MCA's programs, the future of the museum's financial structure was cemented with the issuance in 1994 of $50 million in tax-exempt bonds to fund the new building construction.

With a site secured, programmatic needs defined, and a

strategic operating plan in place, the MCA selected the architect who would give physical form to its ambitious plans. In 1990 the MCA sought nominations from throughout the world and reviewed the work of over 200 architects. This list was eventually narrowed to six masters in the field. The selection committee met with all the architects and traveled throughout the world to experience their work firsthand. Finally, in 1991 Josef Paul Kleihues was selected as the architect best suited to the project, best able to translate the museum's program into a building of distinction.

Kleihues's design for the museum is his first in the United States, following a number of outstanding projects in his native Germany. First unveiled in 1992, his design combines a sensitivity to the tradition of modern architecture in Chicago with a clarity of structure and spirit of innovation—notably in his decision to use cast-aluminum panels on the exterior of the museum. Kleihues's design for the MCA respects the function of the building and lives up to the potential of the site.

Having chosen an architect, the MCA now assembled a team that would oversee the efficient, high-quality construction of the new museum. Architect Kleihues opened an office in Chicago to maintain close involvement in the project. A. Epstein and Sons International, Inc., was brought on board to serve as associate architect. The museum selected Schal Bovis, Inc., as program manager, while Ove Arup & Partners acted as design engineers. This team, under the supervision of MCA staff project manager Richard Tellinghuisen, brought experience and expertise to this most important project in the museum's history. Following demolition of the Chicago Avenue National Guard Armory, groundbreaking for the new museum building occurred in 1993.

With the completion of its new building, the Museum of Contemporary Art stands ready to fulfill its mission and the promise of this extraordinary venture. The exhibition and program schedule will be carefully crafted through joint efforts of the curatorial and education departments. Programming during the first year in the new building will give audiences a taste of what the new MCA is intended to be. The inaugural exhibition, *Negotiating Rapture: The Power of Art to Transform Lives* explores the urge of contemporary artists to push beyond the limits of everyday experience toward a realm beyond human perception. Organized by Richard Francis, Chief Curator and James W. Alsdorf Curator, this challenging exhibition features such artists as Francis Bacon, Joseph Beuys, Anselm Kiefer, Bruce Nauman, and Ad Reinhardt.

The equally ambitious exhibition that immediately follows, curated by Special Projects Curator Lynne Warren, is *Art in Chicago: 1945-1995*. The first comprehensive historical survey of art created in Chicago, "Art in Chicago" explodes the myths surrounding Chicago art and explores the efforts to create and exhibit art in light of the city's politics, social activism, architecture, neighborhoods, and culture.

Perhaps more significant than any single exhibition is the fact that in the new building the MCA will have, for the first time, galleries dedicated to its exceptional permanent collection. Limited to occasional displays in its former building, the MCA's permanent collection is a treasure that has perhaps been overlooked by Chicagoans, despite the fact that it consists of some of the most exciting artworks created and collected in the past fifty years. In the new museum, works from the collection will be on display on a full-time basis, allowing visitors to gain an understanding of recent art history in a way never before possible. It is also expected that the new building will attract future gifts and loans from private collections, like the exceptional bequest of 105 works from the late Gerald S. Elliott—the largest gift to the MCA and one that would be a significant addition to any museum.

The new building will also feature a video gallery, allowing the museum to present an important development in recent art that is often neglected in more conventional museums and gallery spaces. Smaller spaces for temporary exhibitions will allow the MCA to continue to present the work of younger and more experimental artists as an ongoing part of its programming. Finally, the Robert B. and Beatrice C. Mayer Education Center, featuring a 300-seat auditorium, classrooms, conference room, and a 15,000 volume library, will help visitors of all ages gain an understanding of the challenging world of contemporary art. Together, these exhibitions and facilities will allow visitors to explore the exciting interactions that exist among recent art, art of previous generations, and the culture

that surrounds us. We believe that the experience of contemporary art will be enhanced and perhaps even transformed in a museum building designed specifically for that art.

Many museums are like history books, subject to occasional revision but essentially stable and even reassuring pictures of the distant past. Our conception of the Museum of Contemporary Art is that it is like a newspaper, covering breaking stories, providing analysis and perspective, capturing the moment in all of its contradictory, unstable glory. Our new building will be the ideal place to present the art of our day, the ideal way to keep this experience vivid and alive for generations to come.

Kevin E. Consey
Director and Chief Executive Officer

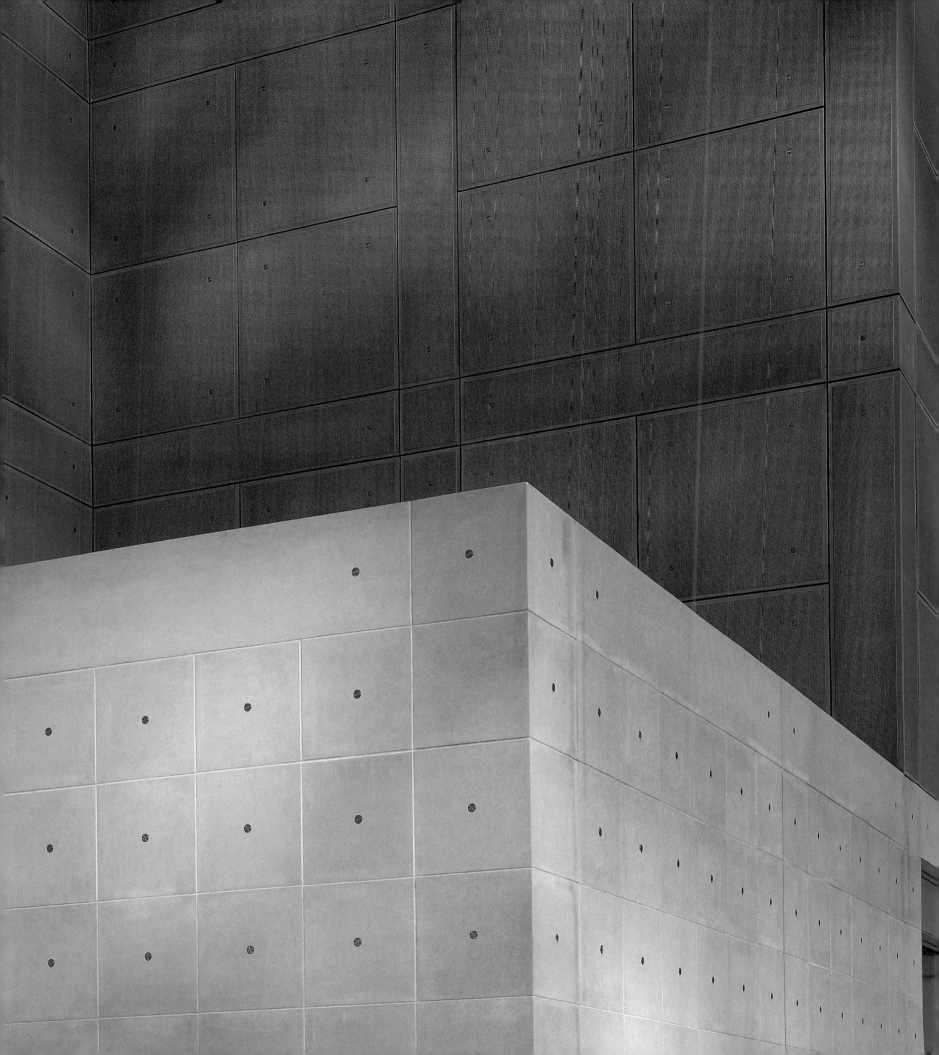

1967

•

*MCA presents
Dan Flavin's first museum
exhibition.*

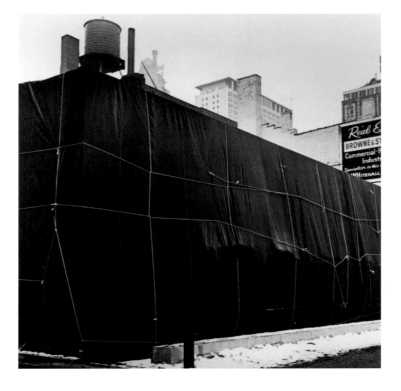

Christo wraps the MCA in
Christo Wrap In/Wrap Out,
1969.

Chronicle: Thirty Years of Change

EVA M. OLSON

Over the past three decades, the Museum of Contemporary Art has carved out a singular presence as a passionate and sometimes irreverent advocate for the art of the moment. Its establishment in the late 1960s created new opportunities for Chicago viewers to experience contemporary art at a time when standard offerings encompassed only the traditional and time-tested. The museum's tempestuous history has mirrored the vitality and turmoil of America's past thirty years. Throughout that time, the MCA has upheld its role as a laboratory for new ideas—experimenting, informing, and illuminating the nature of contemporary art.

The MCA's ongoing commitment to exhibiting art of the present makes consideration of its past particularly intriguing: What has this commitment entailed? What particular responsibilities and enthusiasms has it required? How much improvisation has been needed? How should the wisdom of experience influence a museum that so values the experimental?

Now an established cultural institution with thirty years of maturity, the MCA remains devoted to the innovative and current. Poised on the threshold of its new incarnation on Chicago Avenue, it can best go forward with an instructive sense of its own defining moments. The present soon becomes the recent past and, directly or indirectly, influences whatever ideas and efforts soon follow. So it is in art, and so it is in a growing, changing art museum.

•

THE FOUNDING YEARS The 1960s were a dynamic, turbulent era in America, and the art of the times, often shattering traditional media and content, reflected the political and social unrest many were experiencing. The MCA's arrival during this decade also broke new ground—the museum was a pioneer in presenting current and provocative art.

The Museum of Contemporary Art started as the dream of a small group of postwar collectors with similar tastes, passionate individuals who remained the museum's spiritual parents for many years. As early as 1960, Joseph Randall Shapiro, then chairman of the Program Committee for the Society for Contemporary American Art at The Art Institute of Chicago, was writing to Mrs. Walter (Elizabeth) Paepcke concerning the activities of the society. Their correspondence spawned the

notion of the Museum of Contemporary Art.[1]

Aware of the need for a venue in which contemporary art could be exhibited in Chicago, Doris Butler, Daniel Brenner, Mildred Fagen, Bernard Jacobs, Robert B. Mayer, and Franz Schulze first met on December 18, 1963, to discuss the formation of a new institution. The group was also discouraged by The Art Institute of Chicago's neglect of contemporary art.[2]

Along with Alberta Friedlander, Sigmund Kunstadter, Edwin A. Bergman, and Joseph Shapiro, these were "the people who had the vision and the stamina to pull it together, to organize the body of people that were interested in the same things, to hold them together and get them to coalesce."[3] Fortunately, Joseph Shapiro and each of his "small band of conspirators possessed the four essential ingredients necessary to bring it off: vision, energy, money, and the capacity to part with it."[4]

MCA life trustee and legal counsel Marshall M. Holleb remembers the debates at the early meetings "and the difficulties of thrashing out common purposes. What did it mean to be the museum of just contemporary art? What was the definition of contemporary art at that time? And who would decide? And was it a museum of local artists only? Or were we to be a museum for artists throughout the whole United States—or the whole world?… In 1963 there was hardly anybody who had a view that this would ultimately evolve into a museum of national or international importance."[5]

On January 9, 1964, twenty-five artists, collectors, architects, art dealers, and critics met to formulate plans for the museum. The next month this group, with architect Daniel Brenner as chairman, discussed the US Court of Appeals building located at 1212 Lake Shore Drive as a possible site for a contemporary art center. The Gallery of Contemporary Art was incorporated as a nonprofit organization for the purpose of filling a need in Chicago for a second museum to supplement the work of the Art Institute. The new organization's board of trustees[6] met in November with the museum's location still unresolved; Joseph Shapiro reminded them that the idea of a contemporary art center was more important than the site.

In 1965 mounting bureaucratic and financial tangles promised to preclude the possibility of transforming the Court

1968
•
MCA presents George Segal's first full-scale museum exhibition.

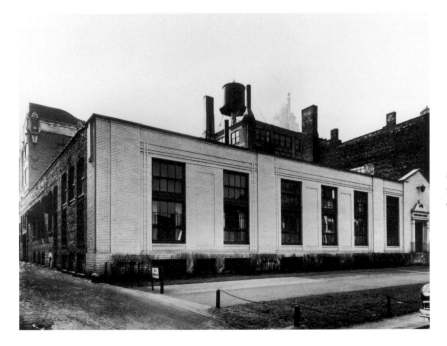

237 East Ontario Street, future site of the Museum of Contemporary Art, circa 1966.

of Appeals building into a viable museum. Alternate sites were suggested, including the Hancock Building and a structure originally built as a bakery in 1915, later serving as the corporate offices of Playboy Enterprises at 237 East Ontario Street. The Court of Appeals plan was ultimately abandoned in 1966,[7] and the board began actively to pursue the Ontario Street structure, logical and desirable because it was located on what was then informally known as "gallery row." Joseph Shapiro announced at a press conference at The Arts Club of Chicago that the museum trustees had signed a five-year lease on the Ontario Street building, which was subsequently redesigned and renovated by Daniel Brenner to become the new Museum of Contemporary Art.

The museum's founder, often described as its spiritual father as well, Joseph Shapiro functioned in the early days of the MCA not only as board president, but chief development officer, marketing director, and occasional custodian. According to Marshall Holleb, "What Joe opened up in our community was an appreciation of art that had not found a focusing point in Chicago. Joe had a strong feeling for art generally and got more intense about contemporary art because it was fresh and there was no other place in Chicago that was showing it at the time."[8] Joseph Shapiro was skillful in communicating his vision, and in guiding others toward establishing a visible and significant presence for contemporary art in Chicago. As he stated in 1967, "What we need in Chicago is a meeting place—an arena for an interchange of ideas about contemporary art, always with reference to the actual material at hand—not just an exhibition hall or a school, but education on an adult, sophisticated level through discourse and communion with original works of art."[9] And his passion and enthusiasm for the daunting tasks faced in the early days of the MCA has remained undimmed. He recently said, "We didn't think anything was difficult. I think it was all a joy. It was an adventure. It was full of our spirit, our enthusiasm, and we just loved every *minute* of it."[10]

Joseph Shapiro was not the only one taking the role of trustee to new levels of devotion. He and fellow pioneers Edwin A. Bergman and Robert B. Mayer took turns spending part of each day in the MCA office, handling day-to-day business operations until staff members were hired.

Fundraising for the first building began, under Joseph Shapiro's eloquent and tireless aegis, a mere six months before the October 1967 opening. Asking corporations to support the newly formed museum was difficult. "I would say 'I'm from the Museum of Contemporary Art,' and they would say, 'The what of what?' They never heard of you because you weren't in existence yet. And it was very difficult. We had no record of performance, but we managed."[11] Significant early contributors included The Chicago Community Trust, the Field Foundation, The Woods Charitable Trust (Art Institute President Frank Woods), and Hugh Hefner.

In the early days the board kept the doors open and the lights on, although the funds to do so often were scarce. As former board president John D. Cartland recalled, "It wasn't unusual in Joe's day to come down to the end of the year and sort of pass the hat and everybody chip in. We were hand-to-mouth during the year."[12] The trustees' dedication to building and sustaining the resources needed to provide quality experiences for MCA audiences has remained a bench mark at the museum.

The Women's Board, the earliest of the MCA's support groups, began with twenty-nine charter members in early 1967, predating the opening of the museum. The following year the Women's Board instituted a docent training program and held their first art auction for the benefit of the museum; they also opened and managed the Museum Store as a mobile unit. Through their multiple efforts, from education to fundraising activities, the Women's Board has been instrumental in shaping the vision of the institution, providing inexhaustible volunteer efforts until funds could be found for a professional staff and then, once the staff came together, continuing to provide invaluable support for the growing museum.

Each step the Museum of Contemporary Art has taken along the path of its development has been influenced by its internal culture as well as the larger cultural, social, and political forces of the moment. To announce the opening in 1967, a brochure stated the purpose and goals of the institution:

The Museum of Contemporary Art is dedicated to the art of today. As no other institution in our community, it will provide a forum for current creativity in the arts. The Museum of Contemporary Art will explore

the new. Its staff will be inquiring in outlook, liberal in viewpoint, and devoted to its task. Its programs will be not only educational, but also stimulating and exciting. This will not be a regional museum but, rather, a gathering place for the best in art today, regardless of where it is produced.

•

The first director, Jan van der Marck, came to the MCA from the Walker Art Center in Minneapolis and quickly developed a reputation for daring, controversial exhibitions.[13] Jan van der Marck saw the museum primarily as a laboratory, a place to exhibit the works of new and untested artists. Although his exhibition proposals occasionally caused stormy encounters with the trustees, they led to a series of groundbreaking MCA events.

The opening exhibition, *Pictures To Be Read/Poetry To Be Seen*, emphasized audience participation and featured sixty-eight works by twelve artists who fused abstract visual elements with text. The artists challenged the very existence of art museums and proclaimed the end of art. Intrinsic to this disconcerting message was the revelation that the MCA would support challenging ideas even, perhaps especially, at the cost of its own comfort. The museum would communicate its support of innovation by giving voice to a message that questioned the young MCA's very existence.

What better way could there be to indicate the museum's unconventional intentions? And what better way could there be to communicate the museum's idea— and *ideal*—of the *kunsthalle*, an institution defined by the presentation of the best possible exhibitions and educational programming? In the early days the kunsthalle model vigorously set the MCA's priorities, and little thought was given to the development of a permanent collection.

Pictures To Be Read/Poetry To Be Seen, along with an exhibition of Claes Oldenburg's *Objects for Museums and Related Drawings*, attracted over 18,000 people in the first six weeks. Next on the schedule was *Two Happening Concepts: Allan Kaprow and Wolf Vostell*; the museum commissioned Kaprow to produce and direct a new Chicago happening.

Nicknamed "The Little Museum That Could" by a local newspaper, the MCA in its early days was, in the words of art critic Alan Artner, "a place where you could expect the

1969

• *MCA is the first major public building in the United States to be wrapped by Christo.*

unexpected. And it generally didn't disappoint in that sense."[14] The museum continued to amaze—and occasionally confound—audiences with its audacious shows. *Dan Flavin: Pink & Gold*, an exhibition consisting of fifty-four eight-foot fluorescent light tubes, received a dramatic response from some viewers. As Joseph Shapiro later recalled: "People would come in, pay their admission fee, walk in, and they'd say, 'Where's the exhibition?' And we'd say, 'This is it.' And they'd say, 'I want my money back.'"[15]

The MCA's desire to educate audiences by encouraging visual literacy and familiarity with contemporary art has been present since its inception. Jan van der Marck believed in introducing challenging work that required effort by the viewer.[16] At a time when the museum staff was small, everyone joined in the attempt to educate the museum's public. "We knew we were doing it by the simplest means. Largely we had to make the *curatorial* effort one of education at the same time."[17] Early discussions of education by the museum's trustees focused on the need to offset popular shows with more experimental work— "balance the new with crowd-pleasers"—while teaching the viewer. Joseph Shapiro noted at the time that the MCA's market comprised a heterogeneous public—"the young, the Silent Majority, and the elitists who read *Art International*."[18]

Initial outreach endeavors included *Art and Soul*, a 1968 pilot project in the Lawndale area under the auspices of the Illinois Sesquicentennial Commission. Representatives of the Conservative Vice-Lords, a former street gang active in Lawndale, approached the museum for advice on bringing art to their community within the framework of a neighborhood rehabilitation program, with arts and crafts classes, exhibitions by black artists, and African artifacts.

The 237 East Ontario land and structure were purchased for $510,000 in 1968. Memorable exhibitions that year included *Made with Paper*, a survey of the creative use of the material, featuring examples from sixteen countries of paper as art form. Atop the roof of the museum appeared papier-mâché figures of a football team, complete with coach and cheerleaders, made by local high-school students. Also shown were *George Segal: Twelve Human Situations*, the artist's first full-scale museum exhibition; *Robert Whitman: Four Cinema Pieces* (which, in lieu

Allan Kaprow's *Words*, in the
inaugural exhibition
Pictures to Be Read/Poetry to Be Seen,
October 1967.

Dan Flavin: Pink & Gold,
1968.

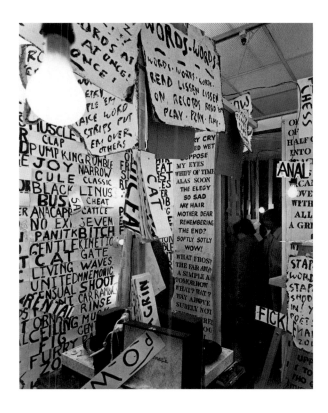

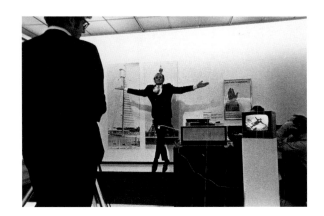

Bruce Nauman's *Jump* being
videotaped for the exhibit on
Art by Telephone, 1969.

of a catalogue, featured a phonograph record on which Whitman sang songs related to the works); *The Original Baron and Baily Light Circus*, in which light, sound, and film converted the lower gallery into a seven-ring environmental circus; *Selections from the Collection of Mr. and Mrs. Robert B. Mayer*, featuring eighty works by seventy-four artists; *New British Painting and Sculpture*; and *Violence in Recent American Art*, a survey including thirty artists, ten of whom were based in Chicago. Chicago artist Ed Paschke, whose work was included in the exhibition, summarized the museum's role: "I think the nature of a museum that addresses the issues of contemporary art is always going to be upsetting to people at times, because that's what it's about. It's about breaking ground, breaking the rules."[19]

In 1969 the MCA continued to take artistic risks when Christo wrapped the building with 8,000 square feet of tarpaulin and rope, an installation that attracted considerable attention—and controversy. According to past board president Lewis Manilow, this exhibition more than any other may symbolize the continuing spirit of the MCA. "It was avant-garde in the best possible sense. That is to say, it expanded the vision of art. We had a grand vision. I remember dancing and cloth being everywhere, and looking at this new building, the whole idea, the scale of the imagination."[20] Visitors were able to enter the wrapped museum and view other wrapped objects. Despite the difficulties of resolving the objections of the fire marshal and the quizzical response of a few trustees, the exhibition was a great public and critical success, and again communicated the daring nature of the young museum.

Also in 1969, following a lengthy debate, the trustees applied their boldness to the cost of admission, doubling it from $0.50 to $1.00. The museum also took the unorthodox step of staying open three nights a week, with staff and trustees stating their belief that a new museum should not be bound by traditional hours of operation. Retrospectives of H. C. Westermann, Franz Kline, and László Moholy-Nagy appeared, as well as *Art by Telephone*, a conceptual exhibition in which thirty-four artists described over the telephone the specifications for works to be executed by the museum staff. *Don Baum Says: "Chicago*

1971
•
MCA presents Enrico Baj's first US museum exhibition; presents first retrospective of Lucas Samara's boxes.

Needs Famous Artists" featured twenty-eight local artists, including works by the Hairy Who, the Nonplused Some, and False Image groups. The final exhibition of the decade was *Selections from the Collection of Mr. and Mrs. Joseph Randall Shapiro*, the first large public showing of 172 works from the Shapiros' distinguished collection. With offerings such as these, the increase in admission price did not deter attendance.

Jan van der Marck believed that the museum could "best strengthen Chicago's artistic pulse by being truly international in scope."[21] He sought to integrate Chicago artists within the broader context of exhibitions.[22] In 1971 the focus shifted with the appointment of Steven S. Prokopoff as director. Emphasizing his wish to focus on Chicago artists, Prokopoff stated that "an institution ought to take care of the [artists] in its own community with the same seriousness that it took care of more celebrated international artists. We really had the field to ourselves."[23] Over the next five years, the MCA evolved in several areas: an increase in exhibitions of local artists, focus on a permanent collection, and more public programming were hallmarks of this period. As the museum matured, it began to develop an institutional self-confidence and expand the ways it fulfilled its mission of education and engagement.

•

The 1970s had arrived, and audiences continued to flock to see innovative shows at the MCA. Openings were drawing 600–900 people and public programs were standing room only. The Men's Council (originally the Young Men's Council) was founded in 1971, and sponsored annual events, including a popular street fair, to fund programs and exhibitions. In 1971 the Education Department was formally established and immediately began an active schedule of lectures, trips, and formal docent training. The MCA Library originated that same year.

Notable exhibitions in 1970 included The Architectural Vision of Paolo Soleri, as well Andy Warhol and Robert Rauschenberg retrospectives. *49th Parallels: New Canadian Art*; retrospectives of Cosmo Campoli and Enrico Baj; *Lucas Samaras: Boxes* (including fifty real boxes plus drawings of imaginary, impossible-to-construct boxes); and *Murals for the People* were presented in 1971. Highlights of the 1972 schedule included *Comix*, a bawdy and brash exhibition of underground comics;

Modern Masters from Chicago Collections, a fifty-year survey of paintings, drawings, and sculpture; works of James Rosenquist; *Deliberate Entanglements*, a fiber show of international scope; and the first major exhibition of the Chicago Imagists, with an opening event/street fair attended by 10,000 people.

In 1973 the MCA featured *Post-Mondrian Abstraction in America*; a posthumous Eva Hesse show; a popular exhibition of Diane Arbus photographs; one-person exhibitions of Richard Artschwager and Alan Shields; and *Joseph Cornell in Chicago*, which included forty boxes and eighteen collages drawn from local collections. Two vastly dissimilar visions of American life were coupled when, along with a Norman Rockwell retrospective, the museum exhibited *Executive Order 9066*, a photographic record of the relocation of 100,000 Japanese-Americans during World War II. Stephen Prokopoff later stated: "That was very deliberate, of course, and the idea was that Rockwell presented an aspect of America that everybody liked to believe—the benign, friendly place—and I wanted to suggest that there was perhaps a darker, meaner side to it."[24]

Initially, the MCA did not seek to establish a permanent collection, in part because the trustees did not wish to compete with the Art Institute.[25] Yet the kunsthalle concept so central to the museum's early days yielded over the succeeding years. No one doubted that the works of unknown and untested artists would always be presented, but it became clear that a permanent collection could support that activity. The trustees became convinced that truly to shine as an institution the MCA needed to pursue a strong permanent collection, especially as the need to present and preserve Chicago's many significant private collections became more apparent. The commitment to such a collection was voiced by Lewis Manilow at a board meeting in late 1973; the following year, the trustees voted to actively develop a permanent collection.

Joseph Shapiro remained president until April 17, 1974, when leadership passed to Edwin A. Bergman. Edwin Bergman's goals were to increase membership and formalize the permanent collection; as well, he was instrumental in the formation of trustee committees. Jim Nutt and Leon Golub retrospectives appeared at the MCA in 1974, along with an exhibition of

twenty life-size figures by sculptors Duane Hanson and John De Andrea. A major retrospective of Alexander Calder opened concurrently with the unveiling of two Calder public sculptures in Chicago. A circus parade led from the MCA to the Loop sites of the other works. The Calder exhibition, the year before the artist's death, holds special meaning for Stephen Prokopoff: "Calder arrived the day before the exhibition opened. It was quite a moment because he could barely walk, he was really tottering." After requesting a hammer, Calder proceeded to fine-tune the works to the specifications he wanted, and "as he moved from piece to piece, slowly, adjusting the works, almost everybody had tears in their eyes."[26]

The museum presented a full complement of public programs at a time when such offerings were rare in Chicago. In addition to artist lectures and gallery talks, a weekly film series, jazz concerts, and an active schedule of performances (featuring such celebrated artists as Philip Glass, Anthony Braxton, and John Cage) showcased the MCA as a center for cultural activity. *Holiday Happenings* at the end of 1974 featured three weeks of activities for "children of all ages" and saw parents and children lined up all the way to Michigan Avenue. Such programs have remained an important means of introducing audiences to the museum and increasing access to its collections and exhibitions. The MCA has embarked on collaborative ventures with several Chicago organizations, including The Poetry Center, which was founded at the museum in October 1974. The first event was *Chicago Poets Look at Paintings*, a reading by over twenty poets of poems based on works of art that were shown as slides during the event. Major writers to appear at the MCA as part of The Poetry Center's reading series included Stanley Kunitz, Gwendolyn Brooks, Galway Kinnell, Allen Ginsberg, and William Burroughs.

Notable in 1975 were *Made in Chicago*, an expanded version of an exhibition that represented the United States in the 1973 São Paulo Bienal and featured twelve Chicago artists, and a Robert Irwin retrospective. The Collectors Group was formed, and MCA membership expanded from 3,000 to 4,500.

But perhaps most exciting that year was *Bodyworks*, an exhibition that remains clearly etched in the minds of those who witnessed it. A survey of over twenty artists, *Bodyworks*

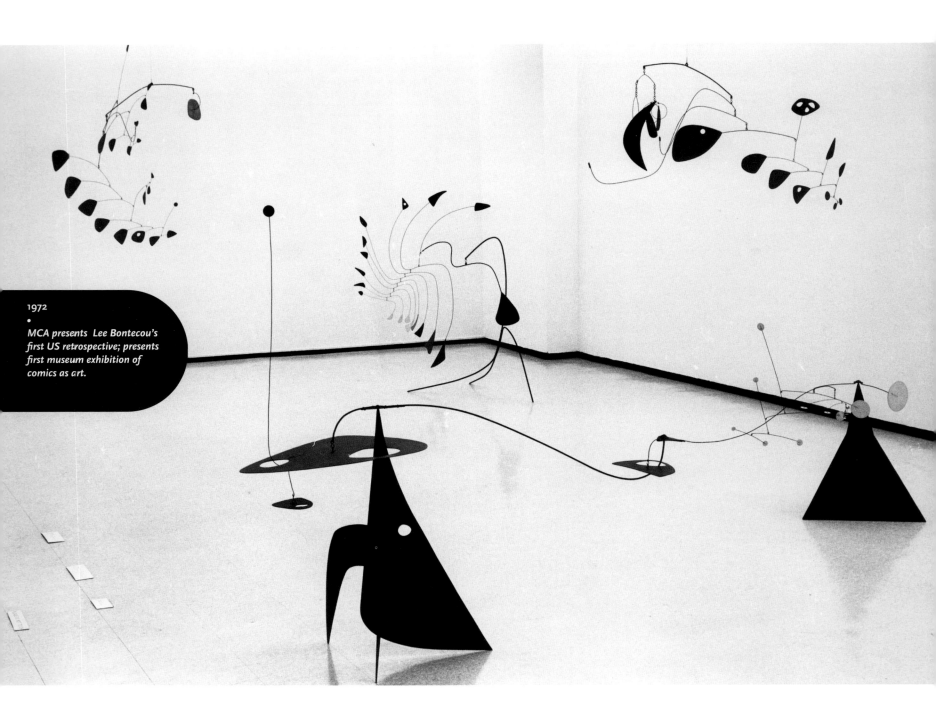

1972
•
MCA presents Lee Bontecou's first US retrospective; presents first museum exhibition of comics as art.

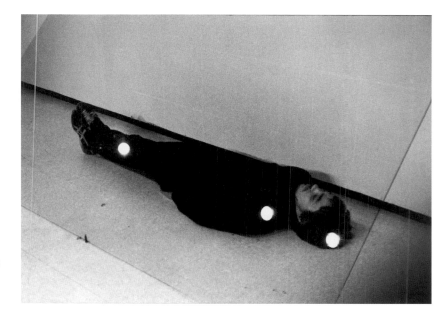

Chris Burden performing in
Bodyworks, 1975.

Left
*Alexander Calder: A Retrospective
Exhibition*, 1974.

was curated by Ira Licht and featured live performances by Vito Acconci, Dennis Oppenheim, Laurie Anderson, and Chris Burden. Burden asked for a sheet of glass, a clock on the wall, and a hammer behind the door, then proceeded to spend forty-five hours lying under the glass while the MCA received national media attention. The press was there in numbers, people came and went, and some even sang songs. Alene Valkanas (then director of public relations) and Licht made the decision to keep the museum open past its usual closing time so that the performance could go on uninterrupted. Eventually everyone went home, returning the next morning to find the artist still in place, and Valkanas remembers, "finally, [MCA technical specialist] Dennis O'Shea, the only one with a Buddhist sense of compassion, filled a pitcher of water, and put it next to Chris's head." As soon as he had done this, Burden got up, smashed the clock with the hammer, and came up to Valkanas with a "grisly" look on his face, really upset. For him, the terms of the piece meant it would be over as soon as someone interfered. "He did not expect to have to endure as long as he did; he thought we would be a museum—museums are formal and structured about their hours, they have unions, they can't make adjustments—that we would come up to him and we would alter the piece by making him leave. He did not realize that he would have to go the long haul."[27]

As it approached its tenth anniversary, the MCA continued to be not only a forum for experimentation, but, increasingly, an institution with a secure presence in Chicago's cultural landscape. The question was no longer how brash could the MCA be, but rather how could adventure and security coexist?

•

A GROWING STATURE: 1976–1985 Lewis Manilow succeeded Edwin Bergman as president in 1976. At a time when both contemporary art and the MCA were gaining increased respectability and attracting a broader public, Lewis Manilow stated his desire to strike a balance between venturesome and popular exhibitions, retrospectives of international figures as well as shows involving local artists. He also reasserted the board's commitment to presenting bold work. "The hunger is for the more challenging. We can be [inspired] by daring, excitement,

and courage."[28] He pledged to move ahead on the permanent collection, and the museum began a formal policy of accepting gifts and bequests.

Surprising and stimulating the curious viewer were now more important than ever. The museum responded to its growing popularity and more secure position as a cultural institution by collecting and presenting the very art that had started it all. By featuring provocative works that celebrated the significance of contemporary art, the museum could provide fascinating juxtapositions with special exhibitions. Postwar artworks would come together under the roof of the MCA and inform a growing audience about the late twentieth century, right up to the present.

These twin goals, presenting both the newest art and a growing permanent collection, accentuated the need for more space. Negotiations were soon underway for an adjacent three-story brownstone at 235 East Ontario Street. Edwin Bergman set a fundraising goal of $1.5 million, to be met by the museum's tenth birthday in October 1977; significant contributors toward the expansion included Mrs. Joseph (Helen) Regenstein and the Kresge Foundation in Detroit. Borg-Warner Corporation provided initial funding for a gallery dedicated to the work of Chicago-based artists.

Chicago-themed exhibitions dominated the 1976 schedule: the MCA's 100th show, *Abstract Art in Chicago*, included fourteen local artists; *100 Years of Architecture in Chicago: Continuity of Structure and Form* featured plans, photographs, and models by 100 Chicago architects and traveled to several European cities. Works by Chicago artists Manierre Dawson and John Storrs were exhibited. Ira Licht was succeeded as curator by Judith Russi Kirshner.

Notable exhibitions in 1977 included retrospectives of Antoni Tàpies, Richard Lindner, and Walker Evans; *A View of a Decade*, a survey celebrating the MCA's tenth anniversary; and Claes Oldenburg's humorous *The Mouse Museum/The Ray Gun Wing*.

John Hallmark Neff succeeded Stephen Prokopoff as director in March 1978. John Neff stated at the outset that his priorities were to complete the building addition, further pro-

fessionalize staff and procedures, place a stronger emphasis on exhibitions and publications featuring European artists, and initiate MCA-sponsored commissions. Prior to the closing of the museum for expansion in the summer of 1978, exhibitions included *Art in a Turbulent Era: German and Austrian Expressionism*; a June Leaf retrospective; and the first Frida Kahlo exhibition in the United States.

In the late 1970s the MCA further expanded its curatorial perspective by commissioning artists from outside Chicago, such as Gordon Matta-Clark, Michael Asher, Max Neuhaus, and Charles Simonds, to create site-specific works. *Circus*, or *The Caribbean Orange*, a piece that combined performance and exhibition, was the final project of Matta-Clark, who used circular cuts to carve out a work of "anarchitecture" in the annex prior to its remodeling into four new galleries. The Max Neuhaus installation was one of the first permanent sound sculptures in an American museum: thirty vertically stacked speakers invisibly placed in the museum's four-story stairwell were each programmed to collectively shape one's experience of the space with sound. Together with Michael Asher's exterior/interior installation, these commissions were the first Conceptual artworks to receive NEA funding as acquisitions for a permanent collection. Concurrent with his retrospective organized by John Neff, artist Charles Simonds created the wall installation *Dwellings* in 1981 for the museum's new Site Café.

Despite bad winter weather and consequent delays, construction on the expanded MCA was completed in March 1979. Converted by architect Lawrence O. Booth into a single structure with a dramatic, light-filled bridge spanning the second floor, the facility more than doubled its exhibition space to over 11,000 square feet. The MCA reopened to rave reviews the weekend of March 24, 1979. During Friday evening rededication ceremonies, *Spotlight on the Museum* featured an installation of 300 sealed beam lights by the artist John David Mooney on the sidewalk and street in front of the building. Inaugural exhibitions included *New Dimensions: Volume and Space* and *Wall Painting*, followed that year by the Michael Asher installation; a Sol LeWitt exhibition; contemporary Latino artists in *Ancient Roots/New Visions*; *Fotografia Polska*, a 140-year survey of Polish photography; *The Complete Drawings of Barnett*

1973

• MCA presents Richard Artschwager's first one-person museum exhibition; presents Alan Shields's first one-person museum exhibition.

Gordon Matta-Clark's
Circus or
The Caribbean Orange
deconstructs
the future museum
annex in 1978.

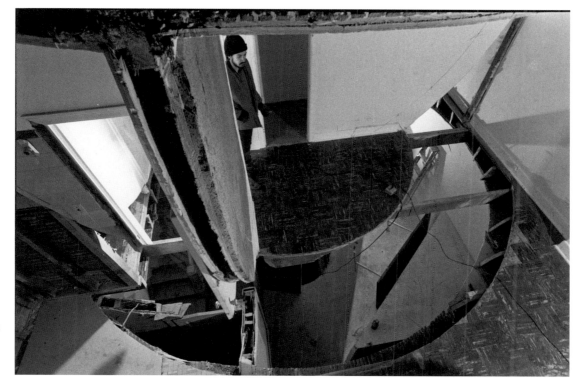

The 1980 Vito
Acconci retrospective
featured
Trailer Camp,
an installation in the
Bergman Gallery.

Newman; and *Outsider Art in Chicago*, featuring Lee Godie and five other Chicago artists. "Options," an ongoing series designed to showcase the work of younger, emerging artists as well as new work by established artists, was launched in 1979 with an installation by Elyn Zimmerman. Contemporary video works were shown in the *5th Annual Ithaca Video Festival* and the *Everson Video Review*.

As had been planned, the expanded space offered more opportunities to exhibit the museum's permanent collection. Annual exhibitions of painting and sculpture in the permanent collection were featured, along with the MCA's collection of artist's books. The Contemporary Art Circle was established in 1979. According to current MCA Director Kevin E. Consey, "The Circle remains the premier individual annual contributor's vehicle for exhibitions and educational programs at the MCA even today, seventeen years later."[29]

Over two-thirds of the ninety exhibitions during John Neff's tenure were organized by the MCA. He noted in 1980 that the MCA "has come to serve a research and development role for other museums,"[30] and that the character of its exhibitions involved taking risks and questioning tradition. Memorable shows in 1980 included a Vito Acconci retrospective (including sculpture, video, poetry, and performance); *German Realism of the Twenties: The Artist as Social Critic*; *Hare Toddy Kong Tamari: Karl Wirsum*; *MA, The Japanese Concept of Time/Space*, an examination of eleven Japanese artists featuring architecture, photography, and landscape design; *Balthus in Chicago*; and the "Options" exhibitions of Martin Puryear, Lawrence Weiner, and Helen and Newton Harrison. It had become clear that a regard for the unconventional in art could be supported by taking steps to stabilize the institution. Hence the MCA began a two-year process of seeking accreditation from the American Association of Museums, recognition that was conferred in 1982.

When the museum expanded in 1978, its dedication to providing a variety of educational programs and activities benefited from the generosity of Beatrice Foods, which funded an orientation space to show educational videotapes related to

1974

MCA presents Leon Golub's first full-scale public museum exhibition.

exhibitions on view. The School Outreach Program, established in 1980, allowed the museum to reach significantly more students with expanded tours, free bus service, and teacher workshops.

Helyn D. Goldenberg became president in 1981. A founding member of the Women's Board, Helyn Goldenberg brought to her tenure the desire to expand the education program, balance the budget, and run the MCA like a business. She was also keenly aware of the need to broaden audiences, and amenities such as The Site Café (which opened in 1981) and the expanded Museum Store were redesigned to attract more visitors. Helyn Goldenberg recently summarized the MCA's history as a venture of extraordinary magnitude, noting that "the failures have been as interesting as the successes, and I think that's fine."[31]

In 1981 The Woods Charitable Fund sponsored a free day on Tuesday, and attendance rose thirty percent over the previous year. Exhibitions included Joan Miró; solo shows of Roger Brown, Chuck Close, and Robert Smithson; *California Performance Then and Now*, cosponsored by The Renaissance Society at the University of Chicago; and video by Chicago artist Skip Blumberg. The MCA originated traveling exhibitions of the work of Margaret Wharton and Charles Simonds. The "Options" series featured works of Jane Wenger, Ritzi and Peter Jacobi, Shigeko Kubota, and the female artist collaborative Disband at the Dustbowl. The critic and collector Dennis Adrian pledged nearly 500 works to the permanent collection—the first complete collection to be promised to the MCA.

By the 1980s the unselfconscious energy of 1970s art was being replaced with a marketing perspective that reflected the times. Visual art, and the artist as creator, were granted a great deal of attention, support, and opportunity—as well as demand. Museums sought to boost attendance with large-scale, blockbuster exhibitions. The burgeoning Chicago "art scene" of the 1980s gained much of its verve from the MCA; in turn, the MCA enjoyed record-breaking attendance.

Highlights of the MCA's 1982 schedule were an Yves Klein retrospective; *Selections from the Dennis Adrian Collection* (organized to commemorate his donation to the museum); more than sixty video works by Nam June Paik; Melvin Charney

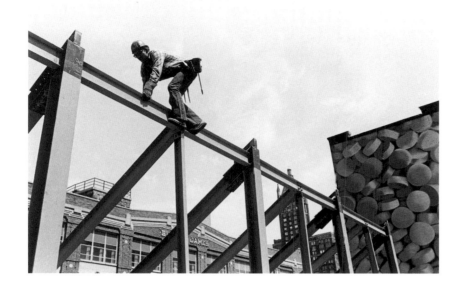

Under construction:
the museum expands its
quarters, 1978.

Rededication ceremonies in
March 1979 feature an
installation by John David
Mooney.

(the Canadian artist's *Chicago Construction* transformed the museum facade); and Laurie Anderson. *New Music America*, an ambitious festival of experimental music, was sponsored by the City of Chicago with the assistance of MCA staff. This half-million-dollar festival took place over eight days at Navy Pier, opened at Orchestra Hall, and was broadcast live. As part of the festival, John Cage's *A Dip in the Lake* was performed aboard the S.S. *Clipper* docked at Navy Pier. The MCA scheduled a benefit at the museum in conjunction with the Chicago International Art Expo in May—an event that moved to Navy Pier the following year and became an annual tradition. The Affiliates, under the aegis of the Women's Board, were also formed in 1982; its members and programs continue to serve as community liaisons for the museum. MCA education programs expanded to include docent visits to schools as well as extensive in-house activities that would become models for educational programming at other museums.

Looking beyond New York toward Europe, the MCA was reaffirming its global awareness by organizing international exhibitions, reflecting European leadership in the art field and the rise of *Documenta*, the international exhibition held in Kassel, Germany, as aesthetic arbiter. Mary Jane Jacob curated exhibitions of such acclaimed artists as Poland's Magdalena Abakanowicz. The artist's first major US retrospective and the museum's most ambitious exhibition to date, the 1982 show boasted outstanding attendance and media coverage. Indications that the MCA would soon outgrow its home on Ontario Street also began to surface, in part due to the massive scale of Abakanowicz's works.[32] The museum placed several of the larger pieces at the Chicago Cultural Center, and MCA leadership began to look toward the future and the possibility of expanding to a much larger facility. Soon after, Beatrice Cummings Mayer noted that "someday we must have another, larger home—we owe it to Chicago."[33]

The Abakanowicz exhibition also signaled the beginning of a greater presence for the MCA outside its own walls. In 1983 an exhibition of works from the permanent collection appeared at a retail space at 900 North Michigan Avenue, with 18,000 people viewing the works in a two-month run. In 1983 the museum began an outreach collaboration with N.A.M.E. Gallery called *Eleven Chicago Artists*, in which the artists' works, along with videotapes and teacher packets, were loaned to Chicago-area schools and senior citizen centers.

In 1983 the MCA exhibited works by Louise Bourgeois and Malcolm Morley; Earth Art selections from the permanent collection; and the famed George Costakis Collection, featured in *Art of the Avant-Garde in Russia*. "Options" included Alice Aycock, *Dogs!*, Peter Joseph, and film and video from the 1983 Whitney Biennial. The permanent collection was further enhanced when Joseph Shapiro and his wife, Jory, promised over thirty works of art, including works by Max Ernst, Marisol, and Enrico Baj. Works bequeathed by the estate of Mary and Earle Ludgin were also shown.

In 1984 the trustees commissioned an independent study of the museum's prospects for growth. The study confirmed the critical need for a new facility. One of the primary goals, voiced by many trustees, was to have sufficient space to keep and exhibit Chicago art treasures in Chicago. Lewis Manilow later recalled the early phases of fundraising: "My happiest moments were going around promoting this idea because I really thought we could do it!… The first and most important moment or phase of fundraising is convincing yourself. It *should* take months—we were lucky about delays because had it come too quickly, we would not have been financially or emotionally prepared."[34]

I. Michael Danoff succeeded John Neff as director in May 1984. Danoff's stated focus was to locate a larger museum facility. Since development of the permanent collection had spanned ten years and reached some 1,400 artworks, he planned to further determine its concept and direction. Highlights of the exhibition schedule that year included *Ten Years of Collecting*, featuring over 200 works celebrating the collection's diversity and excellence; opera set designs by David Hockney; and *The MCA Selects*, paintings and sculpture shown off-site at Marshall Field's. A larger and more diverse MCA audience was introduced to such artists as Anselm Kiefer and Georg Baselitz in *Expressions: New Art from Germany*. *Dada and Surrealism in Chicago Collections* reflected the astonishing local strength of these holdings. Rebecca Horn, Dieter Roth, and Giuseppe Penone were

Nam June Paik with collaborator Charlotte Moorman, wearing *TV Bra*, at the 1982 opening of his exhibition.

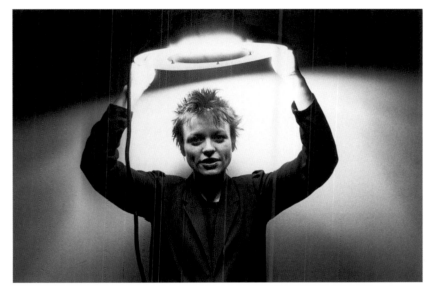

Laurie Anderson performing at the museum in 1982.

Magdalena Abakanowicz's *Abakaus* are installed at the Chicago Cultural Center, as part of her retrospective at the museum in 1982.

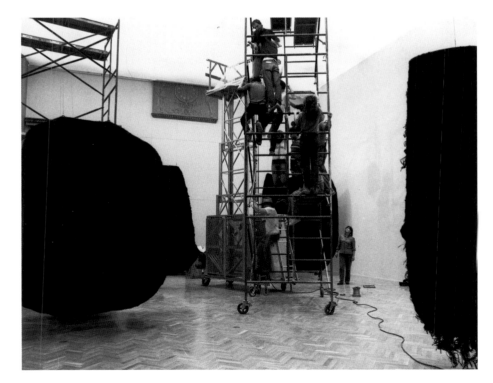

featured in the "Options" series. The New Group, a support group targeted at the growing number of young professionals expressing a strong interest in contemporary art, was initiated that year. With John Cartland as committee chair, the trustees embarked on a long-range planning process.

Exhibitions in 1985 included works by Leon Golub; *Selections from the William J. Hokin Collection*; *The Angels of Swedenborg*, an MCA-commissioned performance by Ping Chong; a Gordon Matta-Clark retrospective; Eric Fischl; and Robert Ashley's *Atalanta (Acts of God)*. The "Options" series featured emerging local artists Paul Rosin, Ken Warneke, Jin Soo Kim, Jo Ann Carson, and Robert C. Peters. Exhibitions of works from the permanent collection included *The Figure in Chicago Art*, a comprehensive survey of American painting and sculpture; *Nouveau Realism and Pop Art*; and artists' books and recordings. The Senior Outreach Program was introduced, sending MCA educators to senior centers and bringing senior citizens into the museum for exhibition tours, workshops, and follow-up activities. The program was acclaimed by the National Council on Aging and became a model for other institutions.

The exhibitions and programs of the early 1980s were at once innovative and popular, and they indicated that expansion would mean far more than building a new, larger facility. The MCA could document healthy growth in virtually every area of the institution. But rather than bask in this success, the museum acted in character: Why stop taking risks? Why not give Chicago an even more energetic and ambitious Museum of Contemporary Art?

BUILDING THE FUTURE: 1986–95 Helyn Goldenberg was succeeded as board president in 1986 by John Cartland. John Cartland's term was distinguished by actions to further professionalize museum operations and consolidate plans for growth.

During 1986 the MCA presented eight thematic installations using works from the permanent collection, which then numbered some 1,647 objects and 1,386 artists' books. The legendary Jannis Kounellis exhibition, his first in the United States,

included installations in off-site locations, as well as works using fire in the MCA galleries. Also shown that year were works by Robert Morris; the retrospective *Mies van der Rohe Centennial*; and *A New Generation from SAIC*, which highlighted the multimedia, high-tech works of sixteen recent graduates of the School of the Art Institute. More than 16,000 students visited the museum, and the *Eleven Chicago Artists* exhibition traveled to twenty-two schools.

As plans to occupy the Armory site advanced from dream to reality, a group of nine trustees gathered at the Hancock apartment of Beatrice Cummings Mayer in March 1986 and committed $5 million as seed money. Plans for the MCA expansion began to crystallize the following month when Governor James R. Thompson appointed a task force to determine the future of the Illinois National Guard Armory located on Chicago Avenue. "We took some difficult chances to bring it all together," Marshall Holleb later recalled. "The State of Illinois Department of Military Affairs announced they were going to get rid of the building on Chicago Avenue. I was particularly stimulated to go get it."[35] Streeterville residents were concerned about the possibility of a high-rise building on the site, and were pleased when the MCA presented a proposal that addressed the need for continued open space. The governor's task force recommended development of the site as a park with a museum and sculpture garden. Marshall Holleb and others began to meet with city and state officials (including the Illinois Department of Conservation, Department of Military Affairs, and Capital Development Board) to negotiate the use of the site, and MCA trustees approved funds for a feasibility study. Late in the year, R.R. Donnelley & Sons offered to donate to the MCA a 145,000-square-foot building at 1910 South Calumet Avenue, which could provide support and space for the MCA. A few years later, when discussions began in earnest with the State of Illinois for the MCA's use of the Chicago Avenue property, it became clear that the Donnelley building would be a suitable home for the Illinois National Guard. John Cartland later noted that "without the Donnelley building we would not have been able to do it. This was the only solution. It was just very fortuitous—the timing was amazing."[36]

In 1987 the MCA organized major exhibitions includ-

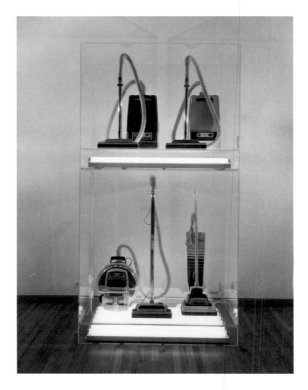

Jeff Koons's
New Hoover Quadraflex,
New Hoover Convertible,
New Hoover Dimension 900,
New Hoover Dimension 1000
was included in his
exhibition in 1988.

ing *British Sculpture Since 1965: Cragg, Deacon, Flanagan, Long, Nash, Woodrow.* Mary Jane Jacob was succeeded as curator by Bruce Guenther. Exhibitions during the year also included works by Donald Sultan and David Salle, and the MCA hosted the comprehensive exhibition *The Spiritual in Art.* Jenny Holzer was featured in the "Options" series. *The MCA at 333 West Wacker* included Minimalist works, Pop Art, and Earth Art from the permanent collection.

The 1988 exhibition schedule featured the work of Christian Boltanski, along with Edward Ruscha, Jeff Koons, and Gerhard Richter. Also included were a retrospective of Nancy Spero; *Three Decades: The Oliver-Hoffmann Collection;* the first public showing of the Marshall Frankel Collection; and the first group exhibition in the United States of Francesco Clemente's *14 Stations.* "Options" featured Odd Nerdrum and the photographers Doug and Mike Starn.

In 1989 the museum hosted *Robert Mapplethorpe: The Perfect Moment,* a traveling exhibition that brought 1,600 to the opening and boasted the highest attendance in the museum's history to date. The Mapplethorpe exhibition did not draw the controversy attendant at other venues, but carried a poignant and memorable note when the artist died of AIDS the day it opened at the MCA. Also that year were *Chicago Artists in the European Tradition;* the MCA-organized *Object, Site, Sensation: New German Sculpture;* three shows of works from the permanent collection; Arnulf Rainer; Peter Saul; the survey *Photography of Invention;* and, in "Options," Mark Innerst and Brazilian artist Tunga. The Keith Haring mural project, jointly sponsored by the MCA and the Chicago Board of Education, brought 500 high-school students to Grant Park to paint a 540-foot mural designed by Haring, who spent several days supervising the project as well as counseling students on the merits of staying in school.

In 1988 the Illinois legislature had passed a bill permitting the MCA to transfer the Donnelley building to the National Guard in exchange for a renewable ninety-nine-year lease on the Armory property, negotiated with the Illinois Department of Conservation. In 1989, as the State moved toward final approval of the title on the Donnelley property and authorization for the transfer, the trustees focused their efforts

on planning the conversion of the Armory site into the MCA's new home. An early endorsement of the MCA's ambitious plans came in the form of a $2 million grant from The John D. and Catherine T. MacArthur Foundation to establish an education endowment for the new facility.

Michael Danoff was succeeded by Kevin E. Consey in November 1989. In the interim between directors, John Cartland appointed Jerome H. Stone as chair of the Government Committee, which oversaw a restructuring process that clarified roles and responsibilities as well as changed titles of trustees and staff. John Cartland was succeeded by Paul Oliver-Hoffmann as the first chairman of the board.

As the museum's director and chief executive officer for the past seven years, Kevin Consey has been responsible for the operations of the Ontario Street museum, implementation of the new museum project, as well as long-term planning for the new building. He sees his role as a continuation of the museum's legacy. "I'm very much aware of the notion of collective work of over thirty years of my predecessors—on the staff, board members, contributors—[and how it] has given the MCA a tangible sense of presence. I feel as the CEO it is my responsibility to respect that presence."[37]

1984

• MCA presents first US exhibition of Rebecca Horn's sculpture.

Also in 1989, under Paul Oliver-Hoffmann's chairmanship and led by Deputy Chairman Jerome Stone, the Chicago Contemporary Campaign was launched. This capital campaign would eventually see the MCA trustees, many of whom were involved in the museum's first incarnation a quarter-century earlier, contributing an astounding sum—more than $38 million toward the overall $55 million goal. As Jerome Stone recently recalled:

When I conferred with our fundraising counsel about the campaign, they talked to me about their evaluation of the feasibility study. They did receive a lot of comments from the leadership in Chicago that it seemed a risky undertaking for a museum that had $2.5 million operating budget to go after a $50 million campaign. It was only after I pointed out that the enthusiasm of the board should guarantee a solid foundation for such a campaign that they felt it was doable. Certainly the "I will" and "Can do" spirit of the board was convincing to me. This campaign has been a leap of faith for all of us, and in all of my fundraising experience, I have never been so inspired and motivated because of the splendid reaching gifts from our board of trustees. I do believe that this inspired all members of Chicago's supporters to join in to make this a successful campaign. [38]

Marshall Holleb noted at a board meeting that the "Miracle on Chicago Avenue"[39] was moving forward: the State approved the title on the Donnelley property late in 1989, and in 1990 the museum officially signed the lease on its new home. The commitment to educating Chicagoans along with other museum visitors continued as Beatrice Cummings Mayer and her family contributed $7.5 million to name a wing of the new museum The Robert B. and Beatrice C. Mayer Education Center. Featuring a 300-seat auditorium, classrooms, and a 15,000-volume library, the center is designed to encourage access and engagement for the museum's growing audiences. Beatrice Mayer discussed the rationale behind the education center:

My children, Robert N. Mayer and Ruth M. Durschlag, and I had long discussed a memorial to my late husband and their father, Bob. With the reality of the new museum the idea of an education center seemed most appropriate. This facility would be a natural continuation of our family's commitment to the MCA from its birth. Bob Mayer educated us all with his passionate desire to communicate the many ways in which contemporary art enriches our lives. My commitment to community service is shared in the way this center will touch so many diverse populations.[40]

•

Expanding its global connections to include the Pacific rim, the MCA hosted an exhibition of monumental sculpture, *A Primal Spirit: Ten Contemporary Japanese Sculptors*, in 1990. Other highlights included a Robert Longo retrospective that drew record crowds; *Toward the Future: Contemporary Art in Context*; *Julian Schnabel: Works on Paper, 1975–1988*; *The Art of Betye and Alison Saar*; and, in "Options," Richard Rezac and Willi Kopf.

One byword for the 1990s is diversity; multicultural artists have begun to play a greater role in art-making, and women artists such as Jenny Holzer and Lorna Simpson have

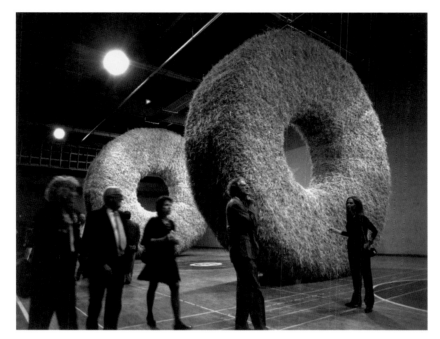

Michael Shaughnessy's
Two Rings/Gathered Rising
was included in
**Art at the Armory: Occupied
Territory,** 1992.

become "art stars" in their own right. Overall, there now is greater prominence for artists outside the dominant (white male) culture. The market concerns of the 1980s have been replaced with a profusion of political and social concerns, to which artists are responding with a multiplicity of new voices and forms. There also has been a progression from 1980s blockbuster to 1990s community, as institutions have begun to approach audiences outside museum walls and in their own neighborhoods.

The MCA's exhibition schedule maintained its diverse character as plans for the new building began to solidify. In 1991 the museum exhibited CUBA-USA: *The First Generation*; the work of Jean-Pierre Raynaud; Sigmar Polke; Rosemarie Trockel; Alan Rath; and *Memory and Metaphor: The Art of Romare Bearden, 1940–1987.* "Options" showcased emerging artists Cheri Samba, Julia Wachtel, and Lorie Novak.

Allen M. Turner became chairman of the board in 1991. He has guided the MCA through the challenging process of architect selection, planning, and fundraising for the new Chicago Avenue structure. After an extensive search, Berlin-based Josef Paul Kleihues, who had designed museums in Germany,

was named the architect for the building in May 1991. Allen Turner's description of the selection process evokes the original priority of Joseph Shapiro and his "small band of conspirators" in the 1960s: a desire to advance dramatically the presentation of contemporary art in Chicago, for Chicago:

When we set out on the journey to build our museum, it was important that the building be architecturally significant, a piece of art in itself, one that contains surprise, but one that does not compete with the art shown inside. We wanted a building sympathetic to its surroundings and context. To do this we decided that the appropriate process was to pick an architect and not a design. Picking a design would not allow flexibility as we developed our program.

In terms of design, we were very concerned about Postmodernism, Deconstructivism, and other current trends. The committee thought such styles would clash with the neighborhood and our art.

We chose Josef Kleihues not only because he had built museums, but because he was a collector of contemporary art and understood what was important about a contemporary art museum. He had been an academic as well as a practicing architect and had a strong

philosophical and intellectual approach that we liked. Also, he had sympathy for and knowledge of Chicago architecture. He was dealing with updated Modernism, similar to the style that Mies van der Rohe brought to Chicago, but a step beyond. The final result—the nature of the materials and their strong gritty presence, the power of the building, its shape, its floor plans—is very Chicago. This building will wear well. I think Chicago will look with great pride on this museum one hundred years from today.[41]

The board approved Kleihues's conceptual design for the building and sculpture garden late in the year. The museum unveiled plans for the new building on March 19, 1992, at a gala celebrating its twenty-fifth anniversary.

In 1992 *Robert Rauschenberg: The Early 1950s*, coupled with John Cage scores from the era, opened to record-breaking attendance. Installations by Donald Lipski and Alfredo Jaar were shown, along with *Lorna Simpson: For the Sake of the Viewer*.

The Lorna Simpson exhibition, curated by Beryl Wright, won the 1993 College Art Association Award for Distinguished Body of Work, Exhibition, Presentation, or Performance. Yasumasa Morimura's trompe l'oeil works were featured in "Options." *Art at the Armory: Occupied Territory* featured eighteen installations in the soon-to-be-razed Armory building.

The museum received a National Endowment for the Arts Permanent Collection grant and initiated a "Permanent Collection Focus" series to allow audiences an opportunity to see selections in anticipation of installation at the new museum facility. By the mid-1990s the collection totaled more than 6,800 works, including 4,384 artist's books and 2,443 works in various media. In addition to the major bequest of Gerald S. Elliott of 105 Minimal, Conceptual, and Neo-Expressionist works, those who have given or promised works to the collection to date include Mr. and Mrs. Edwin A. Bergman, Frances and Thomas Dittmer, Stefan Edlis and Gael Neeson, Ralph and Helyn Goldenberg, Paul and Camille Oliver-Hoffmann, William Hokin, Ruth Horwich, Lewis and Susan Manilow, Mr. and Mrs. Robert B. Mayer, Albert and Muriel Newman, Joseph Shapiro, Howard

and Donna Stone, Lynn and Allen Turner, and other generous individuals and families.

Hand-Painted Pop: American Art in Transition, 1955-1962; Ilya Kabakov; Susan Rothenberg; and *In the Spirit of Fluxus* were featured in 1993. *Conceptual Photography from the Gerald S. Elliott Collection* highlighted Gerald Elliott's significant bequest. The "Options" series featured Libby Wadsworth and Rachel Whiteread.

Richard Francis joined the staff in 1993 as chief curator. *Radical Scavenger(s): The Conceptual Vernacular in Recent American Art* in 1994 was his initial curatorial effort; other exhibitions that year were *Op/Ed*, Fred Wilson's critique of the museum; a Gary Hill video installation; and a series featuring local artists Kay Rosen, Vincent Shine, Hollis Sigler, Jeanne Dunning, and Jim Lutes. Gabriel Orozco and Dan Peterman were the featured "Options" artists.

In its final year at the Ontario Street facility, the museum featured *Franz Kline: Black and White 1950-1961*; *Bruce Nauman: Elliott's Stones*; *Visions of Hope and Despair: Contemporary Photography from Chicago Collections*; *Beyond Belief: Recent Art from East Central Europe*; exhibitions of Wesley Kimler, Jeff Wall, Jack Pierson, Beverly Semmes, Robert Smithson, and Andres Serrano, whose mid-career retrospective concluded the schedule at the Ontario Street site. The MCA expanded its range of education programs with an innovative student docent program, while continuing to offer teacher education and free bus service for Chicago-area students. It also received reaccreditation from the American Association of Museums for another ten-year period.

Groundbreaking at the Chicago Avenue site took place on November 30, 1993, with Jane Alexander, chairman of the National Endowment for the Arts, as keynote speaker. The Kresge Foundation awarded a $750,000 challenge grant to the MCA, which was announced when the building was "topped out" on December 10, 1994. By June 1995 the Chicago Contemporary Campaign had reached ninety-five percent of its goal with $52,317,506 raised. Six- and seven-figure commitments to the Chicago Contemporary Campaign were being made by Chicago's leading corporations and foundations, a ringing endorsement of the museum's expansion plans. Counted among the MCA's key

supporters were Polk Bros. Foundation, The Chicago Community Trust, Robert R. McCormick Tribune Foundation, The Joyce Foundation, as well as corporations such as ComEd, Bank of America, Sara Lee Corporation, First Chicago NBD, AON Corporation. and Johnson Publishing Company, Inc. The staff took occupancy in February 1996, followed by architectural previews, and in June, public preview events and a weeklong celebration for MCA members, donors, and friends.

•

For three decades pioneering exhibitions have paralleled the development of the MCA's own identity. There have been wild "happenings" as well as calm, sophisticated institutional planning. Now the museum takes its vitality and daring to a new venue where it can better reflect and affect the art of our time and its role in our time. As Allen Turner has expressed it: "The building part, as big a challenge as it was, may not be as big a challenge as executing, because when you execute the plan, you step into the world of programming, of scholarship, of service, and those things are more difficult. It's easier to build a building than to fulfill its promise."[42]

Out of this endeavor to realize its potential comes the MCA's paramount obligation: to foster dialogue, solitude, even cacophony—to engage Chicago's residents and visitors in the most stimulating contemporary art.

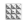

Notes

1 The Feigen Gallery newsletter (July 1960) described the Society for Contemporary American Art's then-current exhibition as "shockingly bad," and said the members had chosen amateur and insignificant works. Melvin Brorby, then president of the society, wrote a response to Richard Feigen, emphasizing the educational aspects of the society: to teach its members to "better understand and enjoy contemporary art" and not to simply give more works to the Art Institute or produce the best shows. Mrs. Paepcke wrote to Mr. Brorby on August 22, 1960, thanking him for the letter to Mr. Feigen, and expressing her dismay with the article. She added: "Out of the [Feigen article] and because of our own disappointment with the Art Institute's attitude toward modern art in general," a meeting was held in the apartment of Richard Feigen with Doris Lane [Butler], Alberta Friedlander and others, in order to discuss forming a museum of contemporary art, in about 1962-63. (*Art in America*, May 1972, notes that until the involvement of Joseph Shapiro, the idea of forming the museum did not gain the motivation and direction it needed to become a reality.)

2 "The Art Institute of Chicago, long the grande dame of the local art scene, was seen as unsympathetic to contemporary art, and its doors were soundly closed to a new group of collectors whose energies and income were committed to contemporary art." James Yood, *New Art Examiner,* February 1986.

3 Marshall Holleb, interview with the author, September 29, 1995.

4 Wendy Hamas interview with Joseph Randall Shapiro, April 14, 1992.

5 Wendy Hamas interview with Marshall Holleb, April 22, 1992.

6 Edwin A. Bergman, Daniel Brenner, Doris Lane Butler, George Cohen, Alberta Friedlander, Byron Harvey, Mrs. Edwin Hokin, Marshall Holleb, Patrick Hoy, Robert B. Johnson, Albert Keating, Sigmund Kunstadter, Richard Latham, Robert B. Mayer, Charles Murphy, Jr., Leo Schoenhofen, Joseph Randall Shapiro, Aaron Siskind, Dr. Joshua Taylor, John Walley, and Edward H. Weiss sat on the first board of trustees.

7 As quoted in *The Chicago Sun-Times,* October 22, 1967: "The bid for the Court of Appeals Building, as board president Joseph Randall Shapiro relates it, was a dreary, soul-destroying struggle, 'like trying to get to Kafka's Castle.'"

8 Marshall Holleb (note 3).

9 *The Art League News* 14, 8 (April 1967).

10 Joseph Shapiro (note 4).

11 Ibid.

12 John D. Cartland, interview with the author, October 4, 1995.

13 Jan van der Marck was quoted in the October 22, 1967, issue of *The Chicago Sun-Times:* "We want people who have something new to say; artists who are not yet accepted; whose ideas are tougher to take."

14 Wendy Hamas interview with Alan Artner, May 6, 1992.

15 Joseph Shapiro (note 4).

16 Jan van der Marck stated: "We will choose the most valid of the traditional ideas, the ones that are always vital and challenging enough to illuminate the contemporary art which is our main purpose... this museum deals in difficult ideas which must never be oversimplified. Contemporary art is not and cannot be simple. It is complex and demands an effort from the viewer. With more and more adult education, more sophistication in every realm of life, the museum has the right to expect a serious effort" (note 13).

17 Jan van der Marck, telephone interview with the author, October 17, 1995.

18 Minutes of Museum of Contemporary Art Board of Trustees, January 20, 1970.

19 Wendy Hamas interview with Ed Paschke, April 22, 1992.

20 Wendy Hamas interview with Lewis Manilow, May 12, 1992.

21 Jan van der Marck (note 13).

22 Quoted in *The Art League News,* April 1967, on the question of whether this is a Chicago museum, Jan van der Marck replied: "It is a far more ambitious undertaking, and I think, in terms of what Chicago needs...it is a national museum...once you set aside certain works of art as being Chicago art or art of Illinois...you in effect are segregating. You are not doing a Chicago artist a service by putting him in a separate room.... And I certainly don't plan anything of this sort. For instance, if we do an exhibition of certain types of painting...you put in such a show artists in Chicago who are working in that medium, along with artists who are working in Paris, Los Angeles, Tokyo, and where have you. And then I think the individual artist will be present with more dignity and more justice."

23 Stephen S. Prokopoff, telephone interview with the author, October 19, 1995.

24 Ibid.

25 "We have had to fend off offers of art works from all round, and could have easily emptied all kinds of attics around the city. Perhaps in a couple of years, we might start putting stuff in warehouses for a permanent collection." Joseph R. Shapiro, quoted in *The Chicago Sun-Times,* October 22, 1967.

26 Stephen Prokopoff (note 23).

27 Alene Valkanas, interview with the author, October 18, 1995.

28 Lewis Manilow, interview with the author, September 22, 1995.

29 Kevin E. Consey, interview with the author, February 12, 1996.

30 Minutes (note 18), June 24, 1980.

31 Helyn D. Goldenberg, interview with the author, September 22, 1995.

32 Helyn Goldenberg recalled that she and Lawrence Booth were walking down Michigan Avenue after a meeting; as she muttered about the Abakanowicz works being too big to fit in the museum space, he asked, "Well, why don't you take the Armory?" They agreed that the best idea was for the MCA to move to the Armory; the rumor spread fast, and Irving Kupcinet picked it up in his "Kup's Column" about three weeks later (note 31).

33 Minutes (note 18), January 24, 1983.

34 Lewis Manilow (note 28).

35 Marshall Holleb (note 3).

36 John Cartland (note 12).

37 Kevin E. Consey, interview with the author, October 24, 1995.

38 Jerome H. Stone, interview with the author, October 20, 1995.

39 Minutes (note 18), April 17, 1989.

40 Beatrice Cummings Mayer, interview with the author, September 29, 1995. Mrs. Mayer was quoted in the 1991 Chicago Contemporary Campaign brochure: "This is a museum for all the people of the city of Chicago and we want to give them every opportunity to visit the museum and we want to make them feel welcome. We also want this new museum to be a meaningful learning and aesthetic experience for families. If we can educate the children of our community, maybe they'll bring their parents in. That's the role our family envisions for the Mayer Education Center."

41 Allen M. Turner, interview with the author, October 10, 1995.

42 Ibid.

1988
•
MCA presents Jeff Koons's first full-scale museum exhibition; coorganizes Gerhard Richter's first American retrospective.

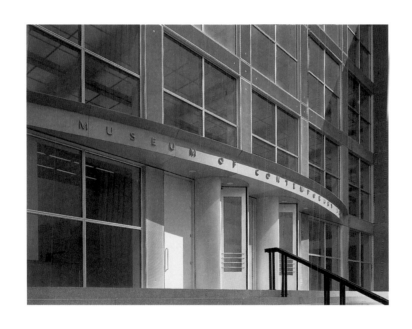

Josef Paul Kleihues: Chicago and Berlin

FRANZ SCHULZE

In the course of the last generation the art museum, especially the type devoted to twentieth-century art, has become the genre of creative choice among the major architects of the world. Public and private institutions have grown as adventurous in their tastes as the artists whose work they exhibit and the architects they hire to provide a frame for that work. It is customary in the 1990s to think of the art museum as a vehicle for the freest expression of its designer's talents and theoretical ambitions.

In a similar spirit of latitude, boundaries of nationality have broken down in architecture almost as completely as they did long ago in painting and sculpture. Distinguished museums have been built in Stuttgart by an Englishman, James Stirling; in Los Angeles by a Japanese, Arato Isozaki; in Frankfurt by an Austrian, Hans Hollein; in London by an American, Robert Venturi—and the list runs on, far beyond these few names and places.

At the same time, it includes architects who, having designed more than one museum, within their home countries or without, have been obliged to tame personal expressive impulses by studying contexts unfamiliar to them and ensuring that the physical character and historical spirit of a specific locale are appropriately articulated in the finished building or, surely, not violated by it. A further constraint often follows from the more than occasional assignment to bond a newly conceived structure to an already existing one.

The art museum, then, challenges resourcefulness as often as it invites license. And among the contemporary architects whose careers have been defined largely by their work in museum design, none is more conscious of the interplay of discipline and freedom, or more responsive to it, than Josef Paul Kleihues of Berlin.

Two of Kleihues's most important recent projects are designs for the Museum of Contemporary Art in Chicago and the Hamburger Bahnhof Museum in Berlin. While the names reflect their commonality of purpose, in an architectural sense they represent for the most part contrasting approaches to that end. The Chicago project has been erected on a choice parcel of land on the city's elegant Near North Side, where it dominates a wide strip extending eastward from one of Chicago's most famous landmarks, the Old Water Tower, to the edge

The site of the Museum of Contemporary Art is between the Old Water Tower to the west and Lake Michigan to the east.

The Hamburger Bahnhof Museum occupies a building constructed in 1846–47 as a railroad station linking Berlin and Hamburg.

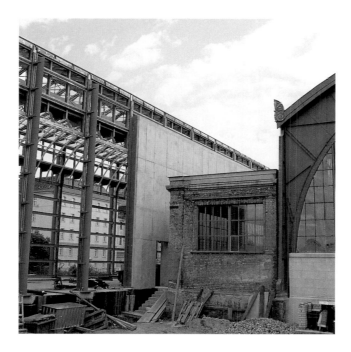

Construction photo of the Hamburger Bahnhof Museum, Berlin

of its equally celebrated Lake Shore Drive and the shoreline of Lake Michigan. The building is altogether of Kleihues's making, an almost unrestricted embodiment of his expressive and theoretical ideas. Its gallery spaces are allocated roughly equally to temporary exhibitions and to the museum's permanent collection, with a sculpture garden effecting a passage between the building and the lake. Auxiliary functions include an education center, a bookstore, an auditorium, and a restaurant, all standard components of today's art museums.

The site of the Hamburger Bahnhof Museum is no less impressive in its own dissimilar way. It lies just immediately east of the line that divided East and West Berlin during the Cold War. The wall that marked that grievous split is now gone, demolished in 1989. The new museum occupies a standing building already rich in a history both inspiriting and depressing. Constructed in 1846–47 as a railroad station linking Berlin and Hamburg, it stood for the high hopes of the Industrial Revolution that galvanized central Europe in the mid–nineteenth century. As other rail facilities were added to Berlin, it was eventually transformed into a transportation and building museum

and still later into a hapless ruin, one of thousands left in the German capital as monuments to the horror of World War II. Restored in the 1980s as an exposition hall, it recently underwent yet another change of identity, this one attached to the art museum that will open in the fall of 1996 following the completion of Kleihues's reconstitutive plans.

In outer form, the Bahnhof museum will incorporate enough of the original structure that its past associations with political conflict and violence will remain rooted in the minds of its Berlin constituency. The interior, while substantially larger in area than the Chicago MCA, will include essentially the same functions. Appropriately, then, each museum in its very materiality communicates a measure of the cultural tradition of the city it represents. In Berlin, the older of the two metropolises, with the more convoluted history, a structure vast, sprawling, and complex in plan consists of parts built at various times in various styles over a century and a half. Younger Chicago, often called the most American of cities, physically untouched by war and famous for its commerce and a collectively pragmatic turn of mind, has gained a building that is clean, compact, confi-

dent, new throughout, and stylistically of a piece. The façade of the Bahnhof museum, the part most visible to the public, retains its typical mid-nineteenth-century Berlin *Rundbogenstil* ("round arch style"), while the Chicago MCA is a recapitulation of the renowned Chicago frame in its elevation, of the Chicago street grid in its plan.

At first glance, then, the two finished works seem strikingly different from each other, one, a Central European hybrid, the other, an American unity. Moreover, while the architect in charge of both is a Berliner, he has left no doubt about his special passion for Chicago architecture. "Even as a student," he has said, "the two cities that interested me more than all others were Rome and Chicago."[1]

Taking him at his word suggests that there may be more of a connection between the Bahnhof museum and the Chicago MCA than appears initially. For one thing both buildings owe more than a little to the classical tradition. The arches, columns, and pilasters of the Bahnhof museum's symmetrical middle tract, together with the embrace of a forecourt by two powerful wings,

attest to this. A similar bilaterality is apparent in Chicago, as well as a comparable winged embrace of a central area, where a monumental staircase rising between the wings brings to mind the ascent to the Propylaea, the great gate to the Acropolis in Athens. The stairs at Chicago lead to an entrance, thence to a formal lobby that crosses the longitudinal axis on the second level. A central hall traces that axis, running the length of the building to the restaurant and a panoramic view of the sculpture garden toward the lake. Parallel to the central hall are the main galleries. On the second level, which is effectively the *piano nobile*, these take the form of two generous, unimpeded spaces two stories high, intended for temporary exhibitions, while their equivalent areas one floor higher are split into two pairs of long rooms meant to house the permanent collection. These latter spaces are the most spectacular interiors of the museum, their glazed barrel vaults providing a capstone to the Classicism that informs the whole structure.

The Bahnhof museum, on the other hand, largely because it was built in fits and starts over decades, departs from

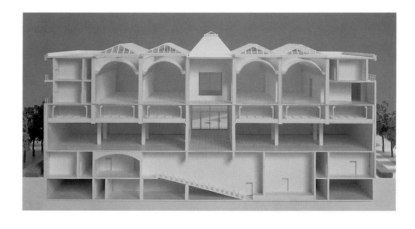

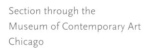

Section through the Museum of Contemporary Art Chicago

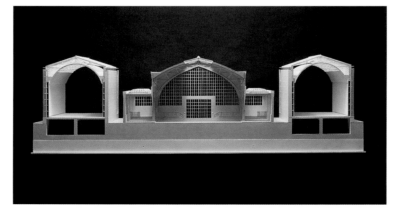

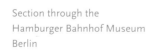

Section through the Hamburger Bahnhof Museum Berlin

the classical paradigm at several points. The great railroad shed, for instance, which will be kept as a space for the exhibition of very large objects, is a piece of unadorned industrial engineering before it is anything else. Moreover, while the interior of the east wing of the old building has retained some of its late romantic relief and stencil ornament, most of the space will be carried out in a contemporary decorative program of utmost simplicity.

The kinships and contrasts in the two museums recall a pair of architects whose careers developed in Berlin and whom Kleihues admires more than any other designers associated with that city. While their shared inclination toward classicism was strong enough to have given Kleihues ample reason to follow it in his two museums, they were also different enough to have left their individual stamps on his finished designs. Karl Friedrich Schinkel (1781–1841) was the more complex and versatile of the two, Ludwig Mies van der Rohe (1886–1969) the more concentrated. Schinkel lived his whole life in or near Berlin. Mies stayed there for roughly three decades before immigrating to Chicago, where his career covered a comparable span.

Schinkel was one of the towering figures of the period suggested by his dates, an era of upheaval in the Western arts when Neoclassicism and Romanticism coexisted, conflicted, and overlapped. The body of architecture that emerged from this collision of forces, like much of the contemporaneous literature, music, and painting, was often epic in scale and no less revolutionary in intent than the radical politics of the time. Schinkel's mastery of classical form is abundantly apparent in his Altes Museum, whose columned façade rises, via a great stair, from a plaza bordering Berlin's splendid boulevard Unter den Linden. Yet it is hardly a work of mere custom, standing instead for one of the earliest efforts to grant the general public access to great works of art earlier available only to the upper classes. The nobility of temper of the Altes Museum derives not from considerations of style alone, but from motives of social progress and public service that Schinkel learned in part from his readings of works by such philosophers as Fichte and Hegel.

Other works meanwhile, like the Werdersche Church and the Kreuzberg Monument, are reminders that he could be Gothic as well as Greek, revivalist as well as revolutionary, even

Romantic and Classicistic at once, as in the seamless blending of free and formal elements in the Gardener's Cottage and Roman Baths at Schloss Charlottenhof. Nor did these widely varying interests preclude a serious study of industrial structures, especially those encountered on a trip to England that prompted him to utilize brick, glass, and iron in the design of several buildings, including a *Kaufhaus*, or shopping center.

This much said, it is instructive to compare Kleihues's motives with those of Schinkel and his two museums with several of Schinkel's works. In the Bahnhof museum the mixture of functional elements with shifting historical styles is reminiscent of Schinkel's willingness to make the most of all constructive possibilities available to him. Fittingly, then, the two wings that Kleihues has added to the northwest and northeast of the middle tract are as Modernist in aspect as the shed between them is industrial. The middle tract itself is framed by a pair of towers that recall similar volumes in Schinkel's catalogue, especially those at Schloss Tegel. The latter work is reflected in Chicago too, the towers flanking its indented front mirrored in the two extending wings of the Chicago MCA. Schinkel's Altes Museum, moreover, addresses Unter den Linden rather as Kleihues's MCA façade faces Mies van der Rohe Way and, at a greater distance, Chicago's own great concourse, Michigan Avenue.

Today such deference to context is associated chiefly with the Postmodernist outlook, less so with the Modernism that movement sought to replace. Yet the Chicago MCA building is as unapologetically Modernist in design as it is indifferent to the historically allusive devices of Postmodernism. There is more reason to trace Kleihues's contextual concerns to Schinkel than to any other source. In the design process, "It is important," Kleihues has said, "to get to know the site first, become fully acquainted with the cultural tradition of a city, discover the 'genius loci,' and only then develop the architecture that is right for both the place and the particular brief."[2]

Even in the one element of Kleihues's Chicago design that seems personally, even willfully, inspired, the example of Schinkel springs to mind. It is the sculpture garden, where the rigorous symmetries and balanced axialities of the building itself give way to a plan dominated by diagonal ramps

Altes Museum
Karl Friedrich Schinkel
Berlin

and staircases, unexpected curves and informal plantings, even an asymmetrically placed pool. Thus organized, three terraces descend from the patio of the restaurant to ground level. The contrast of moods, between calculation in the building and caprice in the garden, recalls the characterization that most critics, following Kleihues's own formulation, have applied to his mature work: "poetic rationalism."[3] The term seems fitting enough, yet one cannot help recalling too that Kleihues is a painter as well as an architect. And so was Schinkel, whose remarkable landscapes of giant Gothic churches silhouetted against a setting sun are among the most arresting documents of nineteenth-century Romantic art.

It should be added that Kleihues's Modernism leaves ample room for elements that orthodox, International Style–type Modernism would have found dissonant and inappropriate. His acceptance of variations in styles and periods in the Bahnhof museum is evidence enough of that. In fact, the cultivation of disparities was central to his 1986–89 design program for the Museum of Pre- and Early History in Frankfurt, where he crossed the nave of a ruined late Gothic parish church with a rectangular Modernist block, effecting a unity of color between the two components but otherwise preserving their strong period differences—even accentuating them by roofing over the nave with a frankly industrial steel truss.

Indeed, among the dozen-odd museum projects Kleihues has designed since 1972, the Chicago MCA may be the least complex in form or varied in historical references. It is thus far the only American commission in his vita, and its attachment to Chicago and a sharply defined architectural culture may help to explain a straightforwardness of design customarily associated with the history of building in this city. While respect for the "genius loci" is one of his fundamental architectural principles, Kleihues has admitted that he is more interested in the Chicago School of Architecture than in the architectural character of the neighborhood surrounding the new museum.[4] Since his design, in fact, suggests considerable respect for that neighborhood, one must infer that his loyalties to the Chicago School are uncommonly strong, and indeed, the emphasis on expression of the structural grid obvious on the exterior would seem to bear this out.

Nevertheless, the overtones of Classicism already dis-cussed here point more to Mies and the Mies-influenced generation of the 1950s and 1960s than to Jenney, Root, Holabird/Roche, Sullivan, or any of the other Chicago pioneers of the late nineteenth century and the early twentieth. Mies, after all, more than any other Chicago architect, was a conscious Classicist, renowned in his own right as a staunch admirer of Schinkel. While clarity, coherence, and concision are hallmarks of his architecture both early and late, they are especially evident in the work of his Chicago period. When he resumed his practice here following flight from the Berlin of the National Socialist years, the uncompromising directness of his design approach proved consistent with a local tradition that he went on to raise to a level of unsurpassed precision and refinement. That his example revitalized Chicago architecture in the 1950s and 1960s is apparent in several of the finest buildings in the neighborhood Kleihues's MCA occupies: the John Hancock Center (Skidmore, Owings & Merrill, 1969), Lake Point Tower (Schipporeit & Heinrich, 1968), the Crate & Barrel Flagship Store (Solomon, Cordwell Buenz & Associates, 1990).

•

Notwithstanding the various influences cited here, it is important to affirm that the Chicago and Berlin museums are finally and foremost the works of a mature artist with his own firmly developed point of view. That Kleihues is no mere epigone of Schinkel is apparent in personal stylistic consistencies, most notably a reliance on the module as the device that both generates and guides the invention of forms. That he has learned from Mies without imitating him may be inferred from a major qualification he has imposed on his fundamental respect for Mies: "I believe that Mies turned away from crafts principles too soon."[5] Indeed, another feature identified with Kleihues's work is the frequent appearance of the humble screw, used partly to underscore its role in structure, partly to animate the surfaces of his walls. Wood, a material often of secondary importance in Mies's realized works, is employed generously, in the form of oak, in the interiors of the Chicago museum, while the rough texture of cast aluminum tempers the smoothly machined geometric frame of the exterior.

Finally, while Kleihues's interest in philosophy may be likened to similar proclivities in Schinkel, Mies, and German

860–880 North Lake Shore Drive
Mies van der Rohe
Chicago, 1948–51

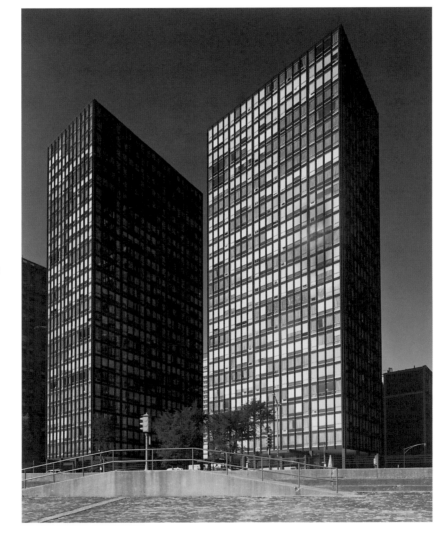

architects as a national group, he has formed conclusions from his reading that are a further sign of independence of thought. Reflecting on the subject of the museum of contemporary art as a cultural institution, he has remarked:

The concept and practice of memory play a strong part in our understanding of museums as places of collecting and preserving, of classification and presentation....What you call our historically understood existence for me includes not only interest [in] but also an active support of development for the future....The German philosopher Adorno, who repeatedly dwells on the question of tradition, discusses the same thing when he comments, "A question doesn't exist that could be asked in which knowledge of the past is not kept, and which doesn't press on ahead to the future."[6]

Notes

1 Unpublished interview with Josef Paul Kleihues, (Chicago: Museum of Contemporary Art, March 10, 1991).
2 "Towards a Poetic Rationalism," interview with Vittorio Magnago Lampugnani, *Domus*, September 1991, p. 30.
3 Ibid.
4 Unpublished interview with Josef Paul Kleihues (note 1)
5 "Towards a Poetic Rationalism" (note 2).
6 Dr. Claus Baldus and Josef Paul Kleihues, Dialogue, *Josef Paul Kleihues: The Museum Projects* (New York: Rizzoli, 1989), p. 41.

Even as a student,
the cities that interested me more than all the others were Rome and Chicago....
As one who has long loved Chicago,
this commission fulfills one of my wildest dreams.

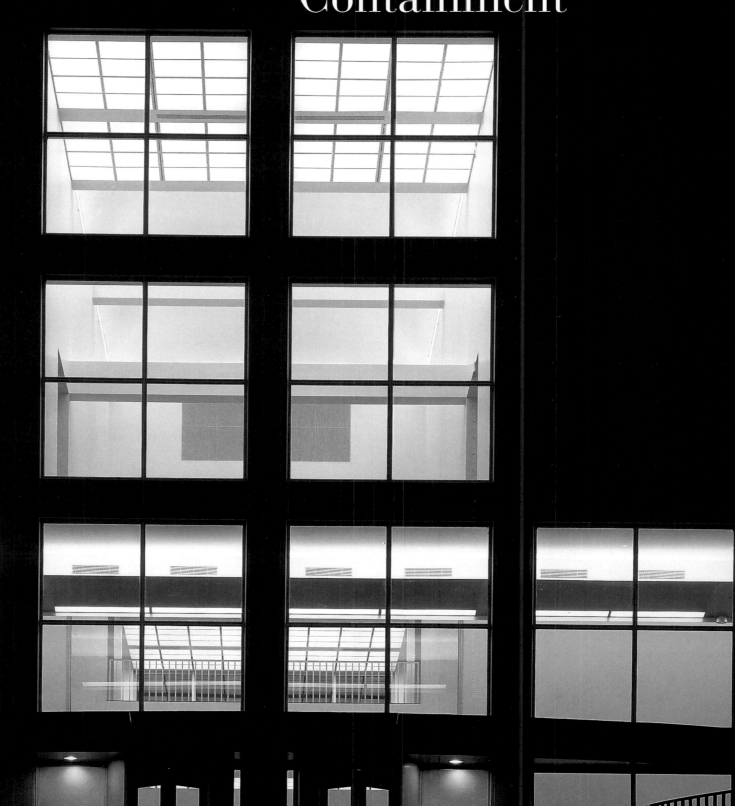

Simplicity, openness, quiet,
as well as the interplay between transparency and containment—these will be the key elements.
You enter the building and look through the axis of the building,
which is transparent, to the lake;
entering from the sculpture garden, you look through the building
to Michigan Avenue.

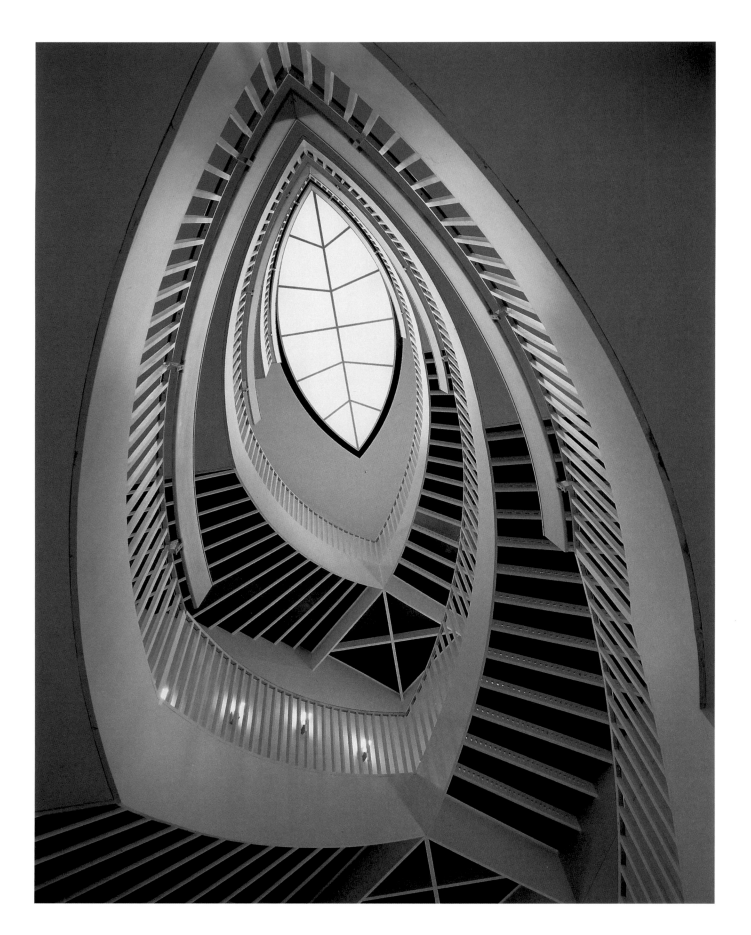

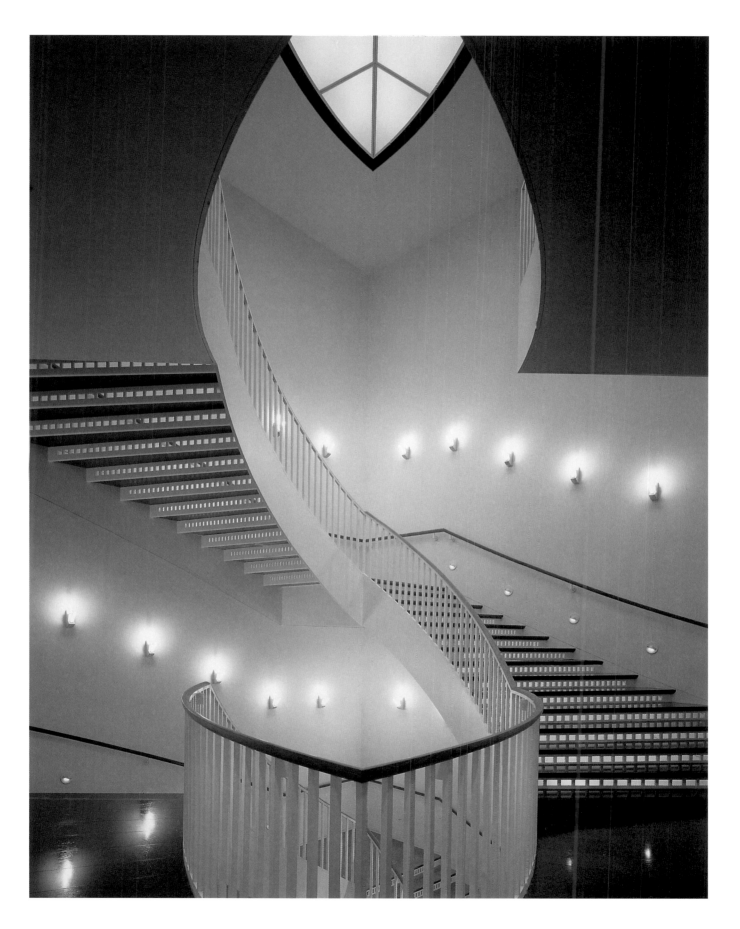

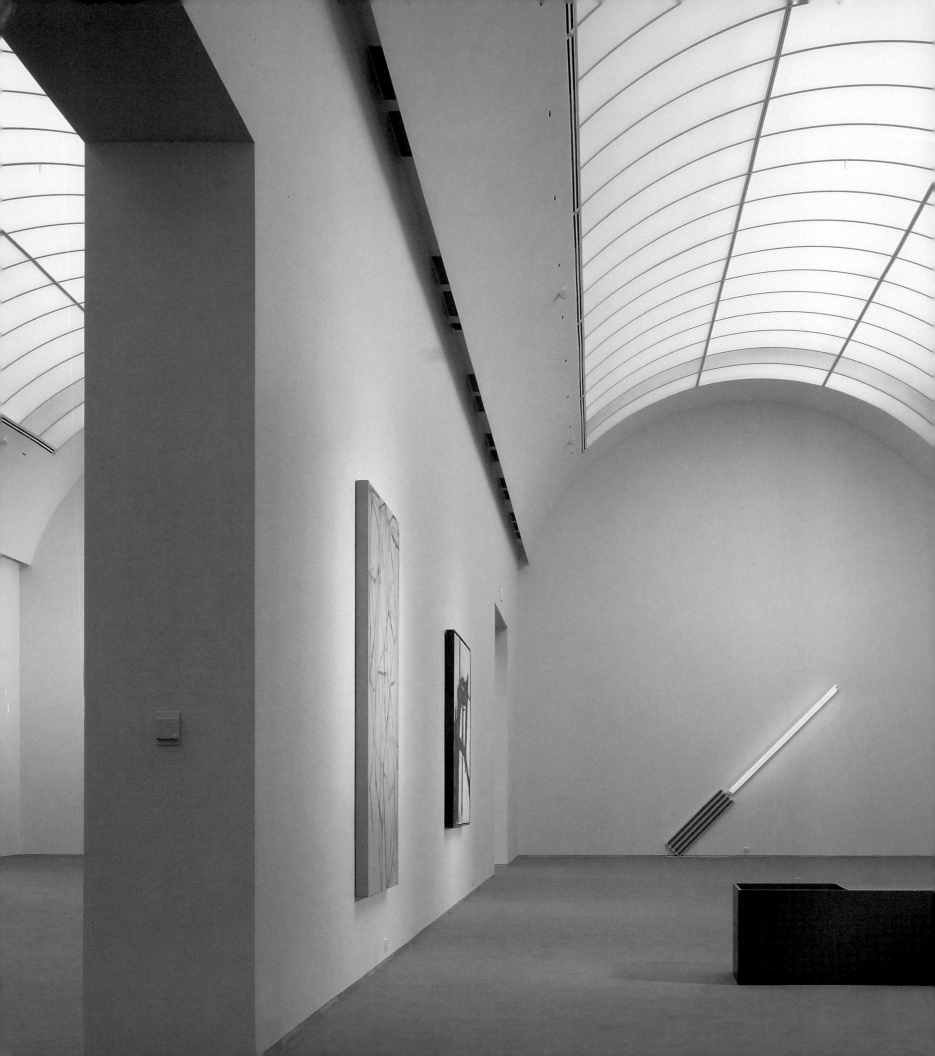

I want the MCA building to be animated,
 while also allowing for the concentrated and undisturbed contemplation of works of art.

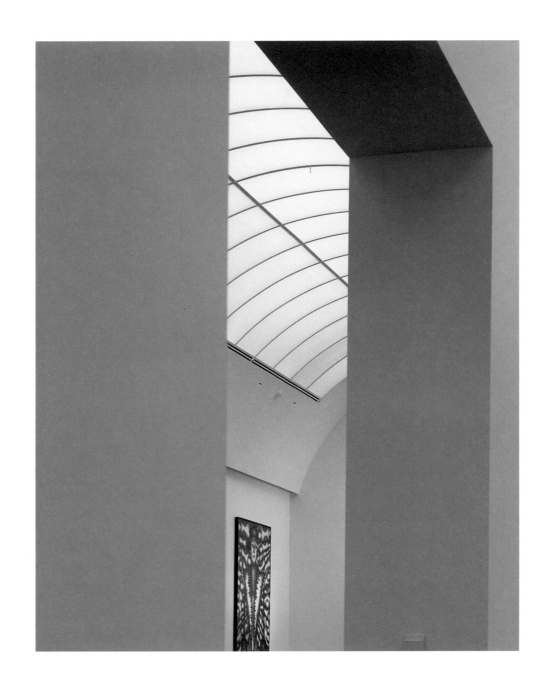

As soon as you enter the exhibition space, you are in some way isolated with the art.
 This is an important concept:
 not to create any kind of environment in that space of the museum where art is displayed.

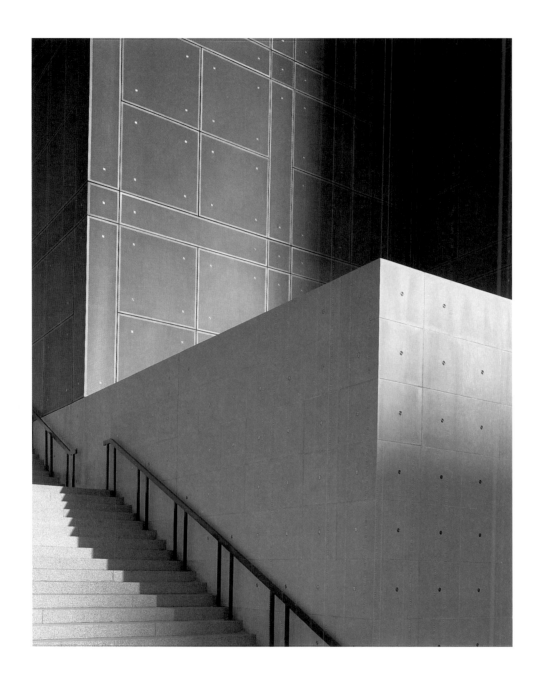

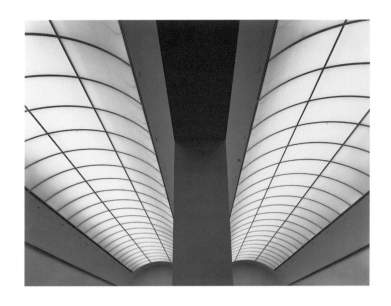

There are very few museums where you have this control and separation of different purposes.

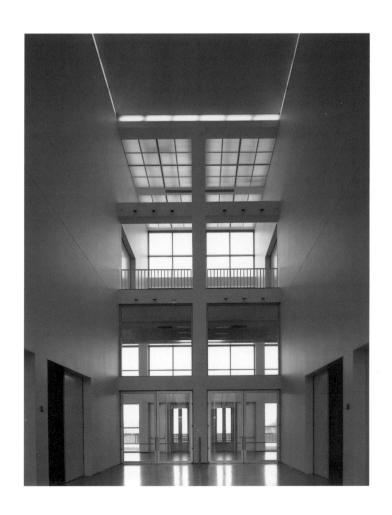

I want the new building to manifest something of the pragmatism
that characterizes Chicago's best architecture and which I consider to be the real Chicago architecture.
I also want it to show something
of the serene reserve that has to do with my theory of "poetic rationalism."

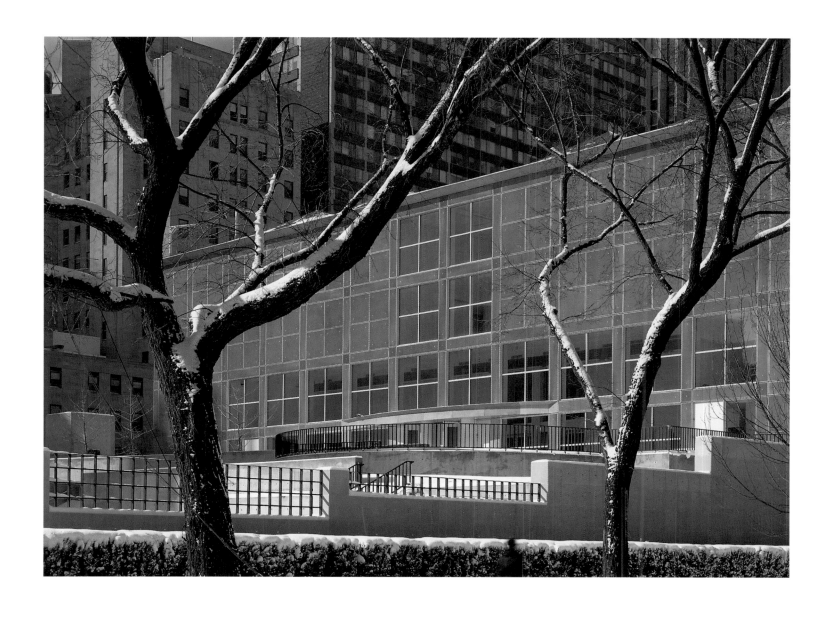

In the Shadow of Storms:

Art of the Postwar Era

RICHARD ARTSCHWAGER

•

American, born 1924

Since the mid-1960s, Richard Artschwager's work has elegantly and intelligently crossed the boundaries between Pop Art, Minimalism, and Photo Realism. Like the Pop artists, Artschwager derived the imagery of his two-dimensional work from magazine illustrations and popular culture; similarly, his three-dimensional sculpture has taken the form of banal, everyday objects—books, chairs, tables, and doors. Artschwager's commercial production background—he operated a furniture factory in New York from 1955 to 1965—undoubtedly played some part in stimulating his interest in the mass-produced or everyday object. It may also have introduced him to the nonart materials, such as Formica and Celotex (an industrial material that can be produced in large sheets), that he uses frequently.

Artschwager's work is simultaneously both furniture and sculpture or painting and object (the three-dimensionality of the painting/objects is created by their substantial scale and by the inclusion of the frame as part of the work). By enlarging or framing the object and denying its functionality, Artschwager sets out to defamiliarize his everyday objects and imagery. In this respect, Artschwager's work is perhaps closest to that of his contemporary Claes Oldenburg, whose irreverent and humorous soft-fabric sculptures depict oversize objects or food. Artschwager's work, however, has a Minimalist simplicity and elegance that sets it apart from that of the iconoclastic Pop artists.

Although the actual view of the apartment room in *Polish Rider I* was taken from a magazine illustration and reproduced, enlarged, with the aid of a grid, onto an enormous panel of celotex, the title refers to

Rembrandt's *Polish Rider* (c.1655; Frick Collection, New York) in which the figure of the rider blocks the point at which the perspectival lines would intersect. In the MCA's *Polish Rider*, Artschwager has chosen an image in which the receding space comes to a similarly abrupt halt, blocked by the apartment's rear wall. In a letter to a curator at the MCA, Artschwager commented that, "In the Rembrandt painting the figure, or the 'wall' is both in repose and in stop-motion; this is also true of the 'wall' in your painting, with somewhat different devices at work." *Polish Rider I* is one of a series of four works that share the same title and represent similar interior scenes with the sharp perspectival recession blocked; none of them bears a direct resemblance to Rembrandt's painting.

Artschwager's practice of restricting his palette to black, white, and gray (or grisaille) for these interior scenes helps to re-create the photographic appearance of the image. The uneven, bumpy texture of the Celotex reinforces the documentary feeling, drawing a connection to the newspaper print from which the image was originally derived. Close up, the image is fuzzy and difficult to read—a quality that has also been likened to the French nineteenth-century paintings of Eduard Vuillard and Pierre Bonnard, whose interior scenes have a similar quietude and record the nineteenth-century bourgeois home.

JM

Polish Rider I

1970–71
Acrylic on Celotex
44 x 60 ³/₁₆ in. (111.8 x 152.9 cm)
Gift of Mrs. Robert B. Mayer
(84.2)

FRANCIS BACON

•

British, born Ireland, 1909–1992

Francis Bacon described the genesis of his paintings as coming from periods of daydreaming when the images would drop like slides into his mind. He used phrases from great literature and images culled from many sources to prompt the daydreams, including, in 1949, the year of *Study for a Portrait*, a medical textbook of diseases of the mouth, a still image of the nurse screaming in Sergei Eisenstein's film *The Battleship Potemkin* (1925), and photographs of war criminals. Bacon appears to have conflated all three sources here, with the most prominent being an image of the dock, a bullet-proof glass box.

Bacon painted early in the day, working quickly in a studio whose floor was often strewn with paper cuttings and photographs. He used the images to trigger memories and to make his recollections more powerful as he tried to express them in paint. Bacon's action in the studio combined the visual actuality of the image with an idiosyncratic understanding of the emotional, psychological, and political implications of what he was using.

In the immediate postwar years, Bacon made a number of pictures with a strange, amorphous shape that in later works becomes more clearly defined as a depiction of the avenging furies of Greek tragedy. The blue shadow in the foreground of this picture resembles the "birds alighting" in *Painting* (1946; The Museum of Modern Art, New York) and the shadows of creatures that appear in the works of subsequent years.

In 1949 Bacon made a group of four images of the head, less portraits than excuses for concentrating on the open mouth, and its glittering sexual potency. Bacon described his ambition to make a portrait of a scream that was equivalent to a Monet sunset: "I did hope one day to make the best painting of the human cry."

When Bacon talked about the box device he used here and in subsequent portraits of Pope Innocent X after the seventeenth-century Spanish master Velázquez, he described it only as a means to concentrate the image. The excitement that he manufactured for himself in part derives from the honesty with which he explored these potentially corrosive subjects and what seems to have been a perverse pleasure in their combination.

Bacon's work proposes a view of the world unencumbered by nicety, while always maintaining a delicate "politesse." The images distend and disturb our sensibility with a troubling exhilaration that is ultimately irresistible.
RF

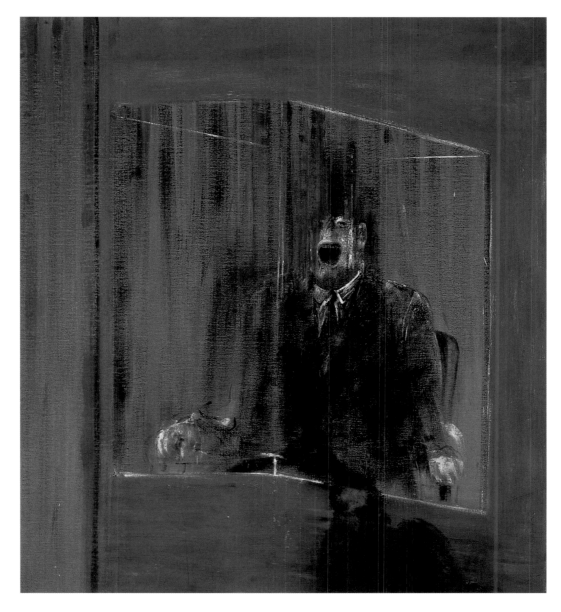

1949
Oil on canvas
58 ¹³/₁₆ x 51 ⁷/₁₆ in. (149.3 x 130.6 cm)
Gift of Joseph and Jory Shapiro
(76.44)

JOHN BALDESSARI

•

American, born 1931

John Baldessari was born and educated in Southern California, where he continues to live, work, and—until recently—teach, primarily at the California Institute of the Arts. The importance of this place on his artistic development is both obvious (the frequent use of Hollywood film and television stills in his mixed-media works) and subtle (he remained relatively untouched by the grandiosity of the New York art world and continued to rely on teaching both as a source of income and inspiration). However, his California residency may also account for the fluctuations in the success of his career.

Having abandoned, and later symbolically cremated, his "traditional" paintings from the 1950s and early 1960s, Baldessari moved rapidly towards Conceptual Art, a movement that in 1970 was just beginning to develop in New York and Los Angeles. Conceptual Art values or emphasizes the *idea*—or concept—over execution. Some of Baldessari's earliest Conceptual pieces are texts on canvas which later developed into combinations of text and photographs, either taken by himself or culled from the media. As with other Conceptual artists who also used text or combinations of text and media, such as Joseph Kosuth and Lawrence Weiner, there was an underlying political dimension to Baldessari's work either in the language itself or in the radical questioning of the boundaries of art.

Among Baldessari's most infamous Conceptual Art gestures are his Commissioned Paintings (1969), for which he hired amateur artists to execute a series of canvases, thereby calling into question the originality of the art object. In 1971 Baldessari staged another notorious event: he assigned a group of his students to write continuously on a gallery wall, "I will not make any more boring art."

His own work developed alongside that of his students in the now famous "Post-Studio Art" course which he taught at CalArts. The no-requirements, no-grades course produced an impressive roster of successful students that includes David Salle, Barbara Bloom, and Eric Fischl.

Baldessari is best known for his photoworks, begun in the 1980s and continued to the present day, in which apparently unrelated film or photo stills are juxtaposed. Linking the images are colored lines that have symbolic or metaphorical associations; flat colored dots block out the faces of those represented, thereby denying the individuality of the subjects. *Fish and Ram* (1988), for example, consists of six color photographs joined together to form an irregular geometric shape. A red line—the red, according to Baldessari, symbolizes danger or abused power—courses through the images.

It begins in a photo of a woman wearing fur that Baldessari has categorized as a typical woman-as-sex-object image, continues through a group of stockbrokers, and becomes a whip in a picture of a man being assaulted. Directly beneath this photo is an image of conformity, soldiers in formation. In contrast to these images suggestive of a violent and constrictive society are two photographs of animals. Although hunted, the fish and the ram, according to Baldessari, are invested with an instinctual wisdom and oppose the image of a rational bureaucratic society run amok.

JM

Fish and Ram
1988
Black-and-white and color
photographs with vinyl paint;
mounted on board
Overall: 109 $^3/_4$ x 144 $^1/_4$ in. (278.8 x 366.4 cm)
Restricted gift of Gerald S. Elliott;
and National Endowment
for the Arts Purchase Grant
(89.2.a-e)

BALTHUS (COUNT BALTHAZAR KLOSSOWSKI DE ROLA)

•

Swiss, born France, 1908

Balthus was born in Paris to a cultured family of Polish ancestry—the son of a painter and an art historian. He began to make drawings as a child in Switzerland, where the family relocated during World War I. In 1924, at the age of sixteen, Balthus moved to Paris in order to immerse himself in art. The Louvre was his academy; he educated himself by copying from the Old Masters, figural and compositional references that would appear repeatedly in his mature works. In Paris, Balthus established influential and lasting friendships with avant-garde writers (particularly poets) and artists, including Diego Giacometti, André Derain, and Joan Miró. Balthus painted *André Derain* (seen with his daughter) in 1936 and *Joan Miró and His Daughter* the following year.

In the early 1940s Balthus began to paint the scenes for which he is renowned—enigmatic bourgeois interiors laden with sexual tension. Like many of his Parisian contemporaries who were involved with the Surrealist movement in the 1920s and 1930s, Balthus leaned heavily on the side of Freudian sexual suggestions in his imagery. The silent dramas are staged in closed interiors—a drawing room or parlor—in which two, sometimes three, self-absorbed adolescents are seen lost in their own abandoned reverie. In their poses and gestures, his youthful subjects bear strong kinship to the children who figured in his 1933 illustrations made for a new edition of Emily Brontë's *Wuthering Heights* (originally published in 1847). Throughout his career Balthus has imbued his figurative works (he is also highly recognized as a painter of pastoral land-scapes) with traces of art history, literature, and theater.

Two Young Girls is one of four closely related works from 1949 in which an adolescent child dozes on a chaise longue, stretching provocatively as if lost in a dreamy awakening of her own sexuality. Although his reclining figure recalls a long and respected artistic tradition of sensual nudes—from Titian's young Venus in *Bacchanal* (1523; Museo del Prado, Madrid) to Jean Auguste Dominique Ingres's *Grande Odalesque* (1814; Musee du Louvre, Paris), Balthus charges the scene with a mysterious tempera-ment of disquiet. Coyly suggestive, but never explicit, Balthus provokes an unclear stasis between what has already transpired and what is imminent.

LB

1949
Oil on board
27 1/2 x 29 1/2 in. (69.9 x 74.9 cm)
Promised gift of
Joseph Randall Shapiro

BERND AND HILLA BECHER

•

German, born 1931 and 1934

Since the late 1950s, the husband-and-wife team Bernd and Hilla Becher have been traveling throughout Germany, Holland, France, and North America documenting in serial photographs no longer functional nineteenth-century industrial structures. Their highly objective photographs are grouped in sets according to the purpose of the structure, and the images are evenly lit without emphasis, and exhibited, as it were, without comment. In the 1950s their work appeared in startling opposition to the expressionist tradition that was generally associated with the German national output, but by the 1970s their work had made a lasting impact on contemporary art by helping to establish the importance of photography for German Conceptual Art.

The Bechers have documented blast furnaces, water towers, grain silos, oil refineries, and *Cooling Towers* (1983) reproduced here, as well as other industrial structures. Each image is enlarged or reduced to create comparable uniformity of size, and framed in grid structures that draw attention to the sculptural rather than the architectural monumentality of the forms. The Bechers, in fact, call their work "anonymous sculptures" and, in many ways, it is similar to that of the American Minimalist sculptors, such as Donald Judd, Sol LeWitt, and Carl Andre, who tried to reduce the art object to its simplest and most striking form.

Although their photographs can be read in opposition to classic art photography's concerns with self-expression, the origins of the Bechers' use of serial documentation can be traced back to the systematic, "objective" records of botanical and human life by late nineteenth- and early twentieth-century photographers August Sander, Karl Blossfeldt, and Albert Renger-Platszch. The apparently obsolete nature of the Bechers' subject matter, however, glances backward in time, as if to take a second, politically savvy, look at the industrial buildings of the Victorian age that originally gave us the obsessive desire to categorize and document: botany, biology, and especially ethnology. Only the Bechers' is a "cool" science, one without recognizable human life.

The very absence of the human beings that created and owned, or even populated, the structures recorded by the Bechers contrasts sharply with the portraitlike intensity of the photographs. This intensity creates characters or personae out of the buildings; they seem to have faces or bodies, albeit "dysfunctional" ones. In contrast to this architectural "humanity," however, is the seriality of the work: the very repetition of *Cooling Towers* undercuts the value of each individual image and ultimately acts as a sort of refutation of the notion that photography can represent a recognizable reality.

JM

 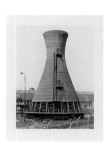

 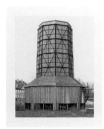 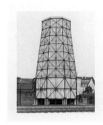

1983
Gelatin silver prints
Twelve parts, each 20 x 16 in.
(50.8 x 40.6 cm)
Gerald S. Elliott Collection
(95.31.a-l)

ALEXANDER CALDER

•

American, 1898–1976

Born in Philadelphia, the son and grandson of sculptors, Alexander Calder first studied mechanical engineering before training at the Art Students League in New York. In 1926, at the age of twenty-eight, he established a studio in Paris. In Paris, Calder made figurative works in wood and wire (one of his first subjects was Josephine Baker, the popular American singer and dancer then based in Paris) and then playful objects, which he thought insignificant, that became his legendary *Circus*.

By 1930, after he had come into contact with such European avant-garde artists as Jean Arp, Constantin Brancusi, Marcel Duchamp, and particularly Joan Miró and Piet Mondrian, Calder's work became abstract. Calder later claimed that this entrance into abstraction resulted from visiting Mondrian's studio, where he told his host that he would like to make Mondrian's colorful rectangles oscillate in space (Mondrian objected). In 1932 Calder constructed his first mobile (a term coined by Duchamp). Over the next forty-four years, Calder created hundreds of abstract "objects" (he preferred this term to "sculpture"), from enormous outdoor constructions to diminutive whimsies of shaped, cut, and colored metal. They are both moving and stationary, some planted firmly on the ground, some suspended delicately from the ceiling. His ideal source of form, in his words, was the system of the universe. In 1932 he wrote: "How does art come into being? Out of volumes, motion, spaces, carved out within the surrounding space. Out of different masses…out of directional lines….My purpose is to make something like a dog, or flames; something that has a life of its own."

Calder's approach to mechanics was simple, bordering on the primitive. He applied his engineering skills only to the degree that his art required. This suited his love of tinkering. He often constructed objects from the scraps of metal and wire that filled his studio. The mobiles evolved from early wire forms which Calder first moved by simple mechanical devices, like hand cranks. Unsatisfied, Calder quickly discovered that through a system of cantilevered and counterbalanced armatures and suspensions, his forms could move freely and independently, activated solely by air currents.

Snow Flurries II (1951) is a large hanging mobile, an open construction of flat white disks, suspended high above the floor. Linked branches of variously sized disks descend from a central wire, the forms quietly swaying and turning as air currents move through and around the surrounding space. The movement is not repetitive; forms dance like leaves on the branches of a tree. The first version of this series, *Snow Flurries I*, is in the collection of The Museum of Modern Art in New York.

Calder returned to the United States in 1933, already widely recognized for his mobiles. He settled in Roxbury, Connecticut, where he continued to live and work until his death in 1976. His first American exhibitions took place in 1935 in Chicago, at the Renaissance Art Society and The Arts Club of Chicago. To this day Chicago maintains a special relationship with Calder's work, particularly visible in major public sculptures such as his *Flamingo* (1974) at the Federal Plaza on South Dearborn Street and *Universe* (1974) in the lobby of the Sears Tower.

Snow Flurries II

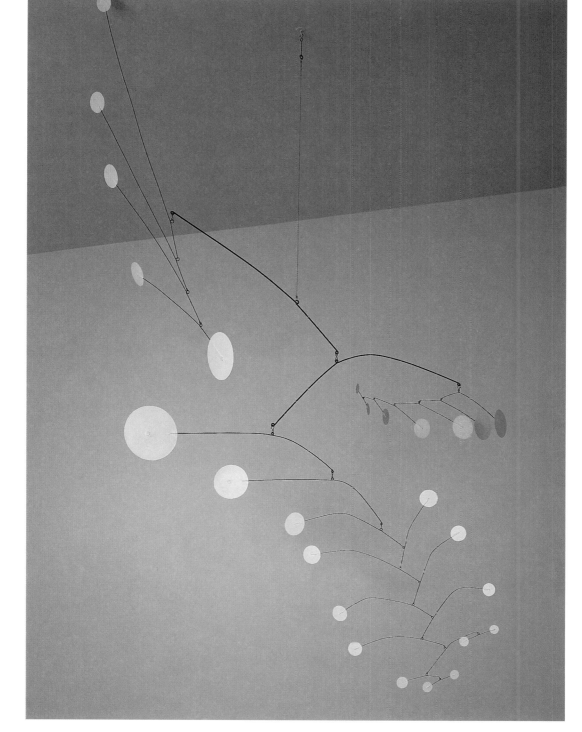

1951
Painted sheet metal and steel wire
96 x 96 x 96 in. (240 x 240 x 240 cm)
Gift of Ruth and Leonard J. Horwch
(83.80)

TONY CRAGG

•

Not only do British sculptor Tony Cragg's sculptures cover myriad materials, but the artist brings a similarly diverse set of approaches and techniques to the making of sculpture. Cragg reveals a remarkable capacity to work in different media: from his wall or floor "drawings" configured out of pottery fragments or plastic rubbish, to carved wooden forms that resemble oversized children's toys, to the more conservative (in material only) bronze sculptures in the form of monumental laboratory flasks and containers.

Cragg lives in Wuppertal, Germany, but was raised and educated in England, receiving his MFA from London's Royal College of Art in 1977. He had absorbed both traditional sculptural modeling and the more recent lessons of Minimalism, Conceptual Art, Earth Art, and Arte Povera when his work started to receive critical attention in the late 1970s. Cragg's earliest sculptures consisted of found refuse—wood, plastic scraps, and bricks—that he arranged into wall or floor mosaics, which he called "drawings." Abandoned plastic products that he collected on the beach in Sussex were separated into chromatic groups and arranged in the shape of one of the objects contained in the color-coded works—an American Indian figure, for example, or a Coca-Cola bottle. These "drawings" have elicited comparisons to Giuseppe Arcimboldo's seventeenth-century trompe l'oeil vegetable paintings; to the sculptures of Richard Long—which use a similar kind of assemblage (although manifesting a romanticism that is completely absent in Cragg's work); and finally to the relief paintings of 1980s artists Julian Schnabel and Anselm Kiefer, which similarly contain broken pottery and debris. Yet Cragg's works also engage with social and material issues that distinguish his art from that of his contemporaries. Although it was clearly a relevant concern, the artist was not primarily interested in condemning the waste and overproduction of a late capitalist, industrialized society. He was determined to give the objects in his "drawings" an after-life by leading the audience toward a reconsideration of the shapes beyond their use-value and to suggest the potential beauty of industrial materials in a weathered, discarded state, and not only as they appear in the pristine Minimalist works of Donald Judd or Carl Andre.

Spill (1987) is part of a series of later works that were cast in steel or, as in this case, bronze, that has been left to rust or to gather a green patina. A comparison of these monumental works to those of the British sculptor Henry Moore, who has dominated the art scene in his native country since the 1940s, is not entirely fanciful. Cragg has vocally taken Moore to task for his grand generalizations on humanistic issues in his thematic sculptural works such as the "mother and child" series. In contrast to Moore's "universal" themes, and consistent with Cragg's scientific interests (he studied science during his university years and is well informed about recent scientific advances), the artist's cast works take the form of gigantic laboratory equipment—retorts, flasks, and test tubes—that have been stretched, bent, and distorted. In *Spill* and other similar works, Cragg has given these instruments an almost humanoid presence. The bodily associations of *Spill*—the magnificently curvaceous bulb and the molten pool that it emits— suggest that the human body, like the flask, is a container and indeed the root of all experimentation.

JM

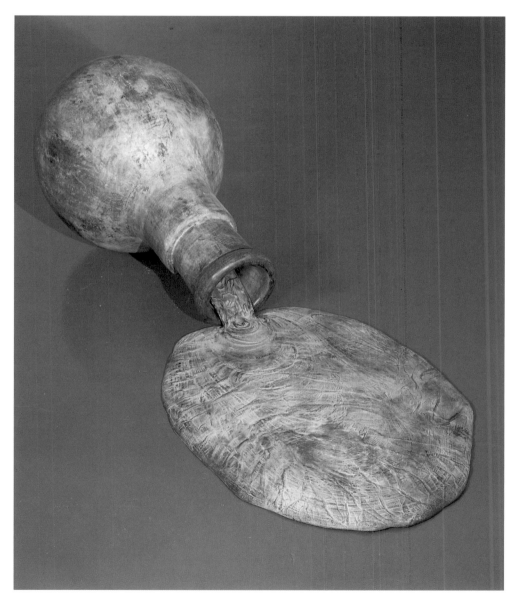

1987
Bronze
39 x 79 x 39 in. (99.1 x 200.6 x 99.1 cm)
Gerald S. El iott Collection
(95.36)

DAN FLAVIN

•

American, born 1933

Dan Flavin was one of the first Minimalist artists to match the use of commercially available, industrial material to a reductivist spirit in art-making. Introducing in the early 1960s his spare works composed solely of flourescent light bulbs, he contributed in truly original and landmark fashion to an investigation of the artwork's occupation of space. While Marcel Duchamp and Robert Rauschenberg, among others, had already introduced the everyday object into the realm of art, Flavin was one of the first to make use of it as a purely formal element. Flavin's more immediate focus on the nature of materials and transformation of space, however, is enhanced by subtle expressions on a more spiritual and personal level.

Flavin was born in 1933 in Jamaica, New York, to a Roman Catholic family of Irish and German descent. He attended the Cathedral College of the Immaculate Conception in Douglastown, New York. In 1953 he entered the US Air Force in Rantoul, Illinois, and then served as an air weather service observer in South Korea. Back in New York, he enrolled at the New School for Social Research (1956) and took art history classes at Columbia University (1957–59). Self-taught as an artist, he developed in the late 1950s primarily under the influence of Abstract Expressionism and Jasper Johns. His exhibition debut, at the Judson Gallery in New York in 1961, included watercolors and constructions. Later that year Flavin introduced light as a material in his "icons," painted wooden boxes with light bulbs attached. His first piece composed solely of light, *the diagonal of May 25, 1963 (to Constantin Brancusi)*, is an eight-foot-long, yellow fluorescent light tube hung at an angle of forty-five degrees to the horizontal.

An early supporter of Flavin's work (and fellow Minimalist), Donald Judd singled out *the diagonal of May 25, 1963* in a review of the first museum exhibition of Minimal Art, *Black, White, and Gray*, held at the Wadsworth Athenaeum in Hartford, Connecticut, in January 1964. Two months later Flavin exhibited more lightbulb works at the Kaymar Gallery in New York, including *the alternate diagonals of March 2, 1964 (to Don Judd)* (1964). *the alternate diagonals* references its predecessor in its angle and in its use of a long yellow bulb. Paying homage to Judd is in keeping with Flavin's dedicating works to artists to whom he owes an aesthetic debt, such as Constantin Brancusi or Russian Constructivist Vladimir Tatlin. The color scheme reflects the palette Judd was using in his sculpture at the time (the MCA's 1962 *Untitled* by Judd is exemplary of this trait).

Beyond the introduction of industrial materials as formal art elements, Flavin's light pieces possess an austere spiritual quality. Referring to the more "otherworldly" connotations of light and illumination, the haunting solitary presentation of the work in the gallery space gives it an ethereal quality rarely found in Minimal Art. Yet, *the alternate diagonals* remains true to Minimalism in its use of light to occupy—and determine one's experience of—the surrounding space. The interplay between the bright gold glow of the long yellow bulb and the darker "field" created by the shorter red bulbs reflects the Minimalists' consideration of color as a necessary vessel of meaning in their spartan visual vocabulary.

DM

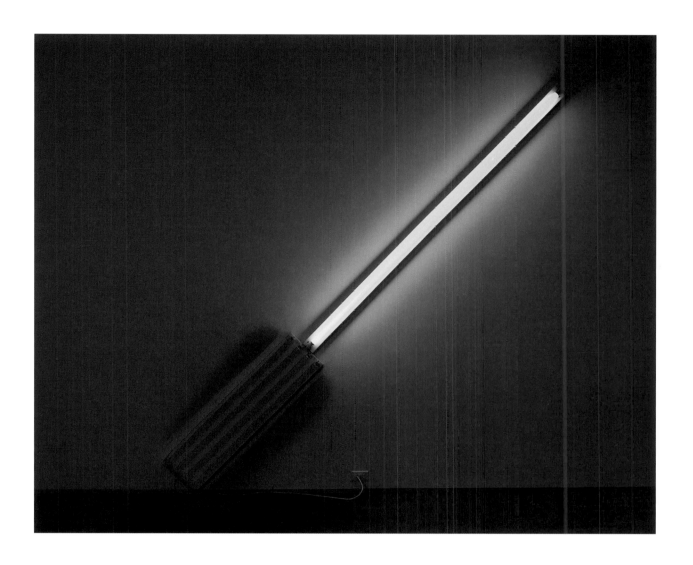

the alternate diagonals of March 2, 1964 (to Don Judd)

1964
Red and yellow fluorescent light
145 x 12 x 4 in. (368.3 x 30.5 x 10.2 cm)
Gerald S. Elliott Collection
(95.40)

LEON GOLUB

•

American, born 1922

Leon Golub has probed the depth and complexity of the human condition throughout his fifty-year career. Although his concern with such issues as power, tragedy, and violence has remained constant, his imagery has shifted from generalized, emblematic figuration to overtly critical and political subject matter. Only in the 1980s, when figurative painting and social content began to command greater interest, did Golub's work receive widespread critical acclaim: the time was right for his explicit scenarios depicting brutal views of white colonialism, American interventionism, and other moments of modern warfare.

While by no means autobiographical, Golub's art has been clearly informed by personal experience. Born and raised in Chicago, Golub studied art history at the University of Chicago before serving in the military during World War II. When the war ended, Golub, along with many returning veterans, enrolled at The School of the Art Institute of Chicago on the GI Bill. His early depictions of wailing and often limbless figures reveal the profound effect of his war experiences. His work was also influenced by African and Oceanic artifacts at the Field Museum of Natural History, Existentialism (American Existentialist Paul Tillich was teaching at the University of Chicago), and Freudian analysis (Chicago was the home of the pioneering Institute of Psychoanalysis).

Golub's early artistic endeavors centered around the exploration of the human psyche: angst-ridden, mythical hybrid forms seem frozen in perpetual agitation, their eyes pleading for peace. Golub shared this type of dark—often grotesque—figurative imagery with other young Chicago artists, whom critic Franz Schulze dubbed the "Monster Roster." Despite this uniquely Chicago-style figuration, however, Golub's attention to the physical act of painting, along with the monumental size of many of his canvases, corresponds with the gestural heroics of Abstract Expressionism, the New York School of painting that dominated postwar American art. His vigorous brushwork and scraping produced dynamic surfaces that contrast with the still and timeless nature of his figures. The figure in the colossal *Reclining Youth* (1959), for example, is rendered with a mottled surface that evokes flayed or burnt skin. Yet the nude form itself, based on the Hellenistic *Dying Gaul* of Pergamon (third century BC; Musei Capitolini, Rome), recalls the monumental stoicism and permanence of classical sculpture. Whereas the model is solid and impenetrable, however, Golub's flattened form with its eroded veneer approaches disintegration.

Golub's interest in Greek and Roman sculpture is evident in his work as early as 1952; European travel heightened this interest. Golub and his wife, the artist Nancy Spero, spent a year in Italy (1956–57) and lived in Paris (1959–64), a stay initially made possible through the sale of *Reclining Youth* to the Chicago collector Lewis Manilow. Based on Roman busts, a series of raw, scraped, generalized *Head* paintings (three of which are in the MCA collection) are equally penetrating studies in the pathos of human nature. Golub continued this series from 1956 until the late 1960s, later embarking on a series of individualized political portraits, which paved the way for his more recent works based on current events and news photographs.

SB

1959
Lacquer on canvas
73 ³/₄ x 163 ¹/₂ in. (200 x 415.3 cm)
Gift of Susan and Lewis Manilow
(79.52)

FELIX GONZALEZ-TORRES

•

American, born Cuba, 1957–1996

Felix Gonzalez-Torres emerged in the late 1980s as one of several young artists who were engaged in invigorating a Minimalist geometric vocabulary by infusing it with content. Using photography, painting, and sculpture, Gonzalez-Torres created quietly evocative works that address social issues and explore the intersection between private and public experience.

Gonzalez-Torres, who died in 1996, was born in Guaimaro, Cuba, and was raised in Puerto Rico. He moved to New York in 1979. His art can be divided into several overlapping series, including works made of stacks of paper, wrapped candies, and strings of lights. His earliest works, dating from 1983, are photographs printed onto jigsaw puzzles. In 1986 he began a series of word portraits commemorating individuals, institutions, or historical events with texts describing significant moments in the subject's history. He enlarged one of these works in 1989 to billboard size for a public project in New York, and subsequently produced billboards with texts or images in several cities. In the candy works, begun in 1990, Gonzalez-Torres created piles of wrapped candies that lie directly on the floor to be consumed by viewers. The following year he introduced a series of works composed of strings of ordinary light bulbs that can be installed in any manner—hung from the ceiling like festival lights or dimmed and lying on the floor, evoking a more somber mood.

Gonzalez-Torres began the "stacks" in 1988. Each stack, comprised of identical sheets of paper printed with a text or image, stands directly on the floor at an ideal height and resembling a Minimalist cube. Paradoxically, what appears to be a sculpture is actually an edition of prints. Viewers may take a sheet. As long as a stack is on view, the supply of sheets is replenished so that the stack never disappears. In this way viewers become participants in the work and collectors of Gonzalez-Torres's art. The stacks confront the conventions of how an artwork functions by undermining the traditionally passive relationship that exists between the artwork and its audience. They also question public and private ownership and the originality and status of works of art. The candy works function in a similar manner—each comprised of a particular amount of candy, determined by weight, which, as viewers consume the candy, is constantly replenished.

Untitled (The End) (1990) is one of Gonzalez-Torres's earliest stacks. Each sheet is white with a black border. The blank central portion acts as a projection space, encouraging viewers mentally to add their imaginings, which are framed in black. Gonzalez-Torres considered his early stacks to be monuments, describing their ideal height as that of a tombstone. His work often focused on a theme of mortality, as the parenthetical title "The End" suggests. *Untitled (The End)* is complete only when the stack is eliminated. Until that point, it exists in a constant, vulnerable state of exhaustion and renewal, functioning as a metaphor for the body.

AC

1990
Offset print on paper
Sheet: 22 x 28 in. (56 x 71 cm), height variable
Restricted gift of Carlos and Rosa de la Cruz;
and Bernice and Kenneth Newberger Fund
(95.111)

ANN HAMILTON

•

American, born 1956

Ann Hamilton, who in 1993 was awarded the prestigious MacArthur Fellowship, established her artistic career with labor-intensive, multidimensional installations that explore communication and perception as processes embodied in a kind of physical, body poetry. She pursues in her art a means to externalize what is felt and sensed, focusing on "the importance of the information that comes through our skin." Hamilton transforms humble materials and imagery into metaphoric portrayals of experience, of attitudes toward existence. Her works ritualize mundane gestures, imagining simple objects and actions on an enormous scale, with an abundance of individual and communal labor.

Using the mechanism of one sense to trigger the perception of another, Hamilton shifts our registry of sense to unexpected parts of the body. Hamilton, who comes from a background in textiles and received her MFA in sculpture from Yale University in 1985, focuses largely on speech, and the acts of speaking and hearing, transformed through often silent rituals into mute, poetic gestures. In her 1991 installation *malediction*, each day over a two-week period the artist sat at a refectory table filling her mouth with mounds of raw bread dough to make molds of the hollow cavity of her mouth, as if giving form to her muted speech. In *tropos* (1993), a year-long installation at the DIA Foundation in New York, the act of walking through the large exhibition space offered a surprising and poetic excursion through the realm of the senses.

Recently, Hamilton has increasingly interwoven moving images into her happenings, performance pieces, and process-oriented works. These four small untitled videos, her first works relying exclusively on video, can be installed as a group or separately as individual works of art. Each monitor is set seamlessly into the wall (the compact mechanics are hidden within the wall). Each video displays a close-up, tightly cropped image loop of the artist rolling pebbles around in her mouth, allowing water to spill into (or out of) her mouth, onto her throat, and into her ear. Her simple, isolated gestures are repeated into abstraction. The four images focus on the points in the body where language is based, where speech is uttered and received. In *Untitled* (mouth/water) (1993) the mouth endlessly rolls around its capacity of small round stones, denying the possibility of speech. Yet, as in *malediction*, speech is re-formed, imagined anew having texture, weight, and capable of movement. Rather than annihilating speech, Hamilton awakens our sensation of communication by means, paradoxically, of the sensuous, that is, tactile (often with erotic associations). Water, in the place of language, fills and spills from the cavities of sound, forming a presence sensed and experienced "through the skin."

LB

Untitled
(ear/water)

Untitled
(mouth/water)

Untitled
(neck/water)

Untitled
(mouth/stones)

1993
Four videos, each 30-minute
video disk, LCD monitor
with color toned image, and
laser disk player
9 $\frac{1}{2}$ x 17 x $\frac{3}{16}$ in. (24.1 x 43.2
x 2.1 cm)

Edition: 6/9
Bernice and Kenneth Newberger
Fund; restricted gift of
Susan and Lewis Manilow and
Howard and Donna Stone
(95.12-15)

ALFREDO JAAR

•

Chilean, born 1956

Two remarkably different maps of the world confront the viewer at the beginning of Alfredo Jaar's installation *Geography=War* (1991). The familiar Mercator map, which gives central position to Europe and concentrates the majority of the land mass in the Northern hemisphere, hangs next to the Peters's map, named after its creator, Arno Peters, which reflects areas of the world according to relative size. The results of the Peters's map are startling: the Southern hemisphere, which contains most of the underdeveloped countries of the world, is almost two times as large as the Northern hemisphere; Europe is relegated to a small Northern outpost.

The differences between the two maps reflect many of the concerns that characterize the Chilean artist's work. Since the early 1980s, Jaar's photographic installations have been involved in questioning Western assumptions and viewpoints. The Mercator map, with its enlargement and central placement of Europe, is just one example of this privileged viewpoint, which reflects its makers' predilections but passes as objective science. Jaar's work is particularly concerned with questions of "place" and the ideological implications behind the terms "center" and "periphery." Typically his work concentrates on marginalized places that are under stress—often due to the collision of wealthy and weakened economies.

Geography=War is the most theatrical and architectural installation that Jaar has produced to date. The three carefully orchestrated sections contain enlarged photographs that Jaar took in 1989 in Koko, a port town in southwestern Nigeria, placed dramatically in light boxes. Between August 1987 and May 1988, five Italian tankers carrying toxic waste arrived in Koko, where a farmer had agreed to store the barrels for $100 a month.

Some of them, pointlessly marked with the international toxic hazard signal of a skull and crossbones, were emptied by locals and used for construction; others exploded in the heat, their contents seeping into the water system. The extent of the toxic contamination has not yet been evaluated.

In Jaar's installation, cinematic light boxes display images of feisty local children playing in the foreground with barrels of toxic waste looming behind them. As the installation progresses, other images are placed on the (hidden) reverse side of the light boxes, and are readable only from their awkward reflection in the mirrors opposite. Frustrating an easy reading, Jaar forces viewers to bend and contort in an effort to "construct" the story. This uncomfortable process makes viewers aware of their own implication in the construction of the narrative and denies the audience "control" over the people of Koko.

By provoking the self-conscious involvement of the viewers and questioning their relationship to the images, Jaar has attempted to avoid the pitfalls of "concerned" photo-journalism. The images become visible only through reflection (in both senses) and the mirrors serve both as distancing devices and, for Jaar, ubiquitous symbols of our narcissistic society.

In the final part of the installation, fifty-five-gallon barrels filled with water are neatly placed in rows. Color transparencies hang from the ceiling, their images— the faces of the children of Koko—perfectly reflected on the surface of the barrels. Once again, Jaar has metaphorically alluded to the impossibility of knowing "them": as one tries to get a closer look, the image disappears to reveal one's own curious reflection. JM

1991
Color transparencies,
light boxes, fifty-five-gallon
metal barrels, and water
Dimensions variable
Gift of Mr. and Mrs. M.A.
Lipschultz and
Maremont Corporation
by exchange
(92.89 a-ddd)

JESS (JESS COLLINS)

•

American, born 1923

The San Francisco–based artist Jess has developed an inclusive and fantastical visual vocabulary in his paintings and collages—including illustrations of fairy tales, Egyptian cosmology, the occult, Victorian imagery, popular culture, and forgotten landscape paintings. Born in suburban Southern California, Jess had remarkably conventional beginnings. After military service, he graduated from the California Institute of Technology and developed a career as a radiochemist in Tennessee and then Washington. It was during the late 1940s that he became an amateur painter.

In 1949 Jess went to the University of California, Berkeley, to start a graduate chemistry program he had applied for under the GI Bill, but, on arrival, he changed to his real subject of interest, art. Hearing of Jess' switch from the chemistry to the art department, the US Government forced the emerging artist to undergo psychological testing. After a short period at Berkeley, Jess transferred to the California School of Fine Arts (now San Francisco Art Institute), where he came under the influence of the school's most renowned teacher, Clyfford Still. Jess' works from the early 1950s were largely transformations of Still's blocks of color in which Jess interpreted abstraction as romantic vision by drawing out references to forms and landscape.

Like the artists of Still's generation, such as William Baziotes, Jackson Pollock, and Adolph Gottlieb, Jess became interested in Jungian archetypes, myths, and symbolism, and by the late 1950s his work contained figurative and Surrealist forms. During the 1950s the artist became immersed in the Beat poetry groups that flourished in the Bay Area; it was here that he met the poet Robert Duncan, who was to become his long-term companion and collaborator in the development of his fecund iconography. It was also around this time that he dropped his last name.

Literary references abound in Jess' work, both in the form of excerpts of text taken from a wide range of authors and used as accompaniments to his paintings, and in the form of pictorial allusion to or illustration of fairy tales and stories. His first "paste-ups" (his term for his collages) that combine engravings, magazine pages, jigsaw-puzzle pieces, text, and cloth were inspired by Max Ernst's Surrealist collages.

For *Midday Forfit: Feignting Spell II* (1971), which represents spring in a series of the four seasons, Jess assembled a phantasmagoria of images, culled from magazines, engravings, tapestry, and found objects. The juxtaposition of images of fruition and rebirth, although seemingly random, in fact suggests numerous visual and verbal puns (such as the phonetic joke implied by the positioning of a Koala cub next to a Coca-Cola bottle cap), although many of these references are private, opaque to all but the artist. The images, which include Egyptian columns, the peasants from Jean François Millet's *The Gleaners* (1857), the Hindu god Shiva, and a Victorian child in imminent danger of being run over by a 1960s sedan, all collide in a composition that stays remarkably coherent. One of the quotations chosen by Jess to accompany the Four Seasons perhaps reveals the method behind the artist's "madness." Quoting Heraclitus, he claims that, "an unapparent connection is stronger than an apparent one."

JM

1971
"Paste-up": magazine pages,
jigsaw-puzzle pieces, tapestry,
lithographic mura , wood,
and straight pin
50 x 70 x 1 ¾ in. (127 x 177.8
x 4.4 cm)

Restricted gift of MCA's
Collectors Group, Men's Council,
and Women's Board;
Kunstadter Bequest Fund in honor
of Sigmund Kunstadter; and
National Endowment for the Arts
Purchase Grant
(82.30)

JASPER JOHNS

•

American, born 1930

The title of Jasper Johns's 1961 painting *In Memory of My Feelings—Frank O'Hara* refers to a 1958 poem written by Frank O'Hara, the writer and curator at The Museum of Modern Art in New York. Johns had become a friend of O'Hara's; they would later collaborate on a print which used an extensive impression of the artist's skin made by rubbing oil on his body and printing it on paper. There is also a sculpture, completed in 1970, in which the poet's foot, cast in rubber, creates an impression on a sandbox. O'Hara, a renowned and fashionable member of the art world, died in 1966 in an automobile accident on the beach, five years after this painting was finished. It is often assumed, wrongly, that the painting is a memento mori. Rather, it is a meditation on the vulnerability of friendship and the shortness of life. O'Hara's poem concerns his love affair with the painter Grace Hartigan which had recently ended;

Johns's relationship with Robert Rauschenberg had similarly foundered and this may be reflected in the work's somber melancholy.

The painting is made on two panels on which are shown hinges as if they could be closed (to hide the subject, conceal the feelings). The left is brushed thinly in veils while the right uses thicker, more expressive paint. Using the devices of Abstract Expressionist picture-making, Johns returned to an emotional subject directly related to him—his own feelings—although the principal component is veiled under the top layer of paint. In this work and in a painting considered a companion, *No* (1961; National Gallery of Art, Washington, DC); and in works such as *Periscope (Hart Crane)* (1963), based on poems by Hart Crane, Johns came closest to showing his own sensibility and the vulnerability of his sexuality. As in several works of this period and

later, the subject of the work or the emotional trigger is buried within the picture. Here, the subject is painted and then concealed below a second layer of paint. X-rays show a crude skull drawn in thick impasto at the top right of the picture and the words "dead man" stenciled at bottom right. (Both are visible as *pentimenti* once one is aware of them.) They give the painting an uncanny foreboding as if they prophesy death itself rather than the end of friendship. The skull was the subject of a concurrent notebook meditation where Johns wrote of inking and printing from it, much in the same way he would make the skin drawings. It can be related to numerous images in the Western tradition of the philosopher in his study, contemplating his own mortality and the brevity of life.

Johns has suspended, on a wire in front of the painting, a fork and spoon bound together. These implements,

used to consume and nourish, also become, in Johns's iconography, potent symbols of mortality. The ideas of consumption, using up, and of the comfortable spooning of the implements, become, by extension, an expression of loss, of love and, ultimately, of life.

RF

1961
Oil on canvas with objects
40 x 60 x 1 ¹/₂ in. (101.6 x 152.4 x 3.8 cm)
Partial gift of Apollo Plastics Corporation
(95.114)

DONALD JUDD

•

American, 1928–1994

From the early 1960s, Donald Judd's criticism and artistic output were produced in reaction to the domination of the American art scene by Abstract Expressionist painting. Judd's ambition was to purge contemporary art of the figural and metaphorical associations he perceived in Abstract Expressionism, and to reduce the art object to its simple and literal essentials. The artist's earliest works were on canvas, and although he rapidly moved on to designing three-dimensional pieces for fabrication, he continued to think of his art, which generally hung on the wall, as comparable to painting rather than sculpture (a term he never applied to his own work).

Judd is famous for his central and strategic role in what was variously to be called Literalist Art, Primary Structures, ABC Art, Object Art, Specific Objects (Judd's own term), and, more durably, Minimalism. The MCA's

Untitled (1978)—a very early concept fabricated in a work of a later date—is an example of the remarkable simplicity of the first Minimalist works. The concept fulfilled Judd's desire to create a single, unitary shape that does not contain the illusory depth of painting or traditional compositional devices. To enhance the immediacy and the extreme simplicity of the form of *Untitled*, Judd painted the box cadmium red.

Singular forms, like *Untitled*, gradually ceased to satisfy Judd's ambitions, however, and he began to produce serial works in which the separate, and often identical, elements were placed in horizontal or vertical arrangements to create carefully balanced and echoing installations. One such example is *Untitled (August 28, 1970)* (1970), in which the order of the units is, in Judd's own description, "not rationalistic and underlying but...simple order, like that

of conformity, one thing after another." An additional interest in light and reflection—bringing his work closer to the fluorescent light pieces of Dan Flavin rather than to that of the other Minimalists such as Sol LeWitt and Carl Andre, whose work was more involved in the structure of solid forms—is apparent in the expansion of industrial materials Judd used beginning in the late 1960s. *Untitled (August 28, 1970)*, for example, combines a translucent green Plexiglas with stainless steel, thereby giving the work a lightness that dematerializes the otherwise obdurate forms. These serial pieces ("stacks" such as *Untitled [August 28, 1970]*, and horizontal "progressions") were produced in numerous permutations of luminous colors and materials—blue, red, green, and purple with bronze, stainless steel, and aluminum—throughout the 1970s.

JM

Untitled
(August 28, 1970)

1970
Stainless steel
and Plexiglas
Ten parts, each
6 x 27 x 24 in.
(15.2 x 68.6 x 60.9 cm)
Gerald S.
Elliott Collection
(95.50)

FRANZ KLINE

•

American, 1910–1962

In 1950, when Franz Kline started to work on the stark, black-and-white abstract paintings for which he is now renowned, other artists of his generation had already experimented with a similarly reduced chromatic scheme. Willem de Kooning's black-and-white enamel paintings (1946–48), Barnett Newman's black-on-black *Abraham* (1949), and Robert Motherwell's black-striped *At Five in the Afternoon* (1949), for example, were all produced before Kline's mythical "breakthrough" (as the artist's departure from a figurative to an abstract style has frequently been called). Kline's development up until 1950, however, has little in common with that of the artists associated with Abstract Expressionism (who, almost without exception, shared an initial interest in Surrealism and symbolic form).

Kline trained as a graphic artist in his youth and received academic artistic training at Boston University and the Boston Student's Art League (1931–35) and subsequently at Heatherly's Art School in London (1936–38), during which time he mastered a conservative, descriptive draftsmanship. During the 1940s Kline's work became more expressionist, but his subject matter remained representational and generally consisted of landscapes and portraits. Whether Kline's art underwent an overnight transformation, however, has been disputed. It is generally agreed that the origins for his post-1950 works are contained both in his training as a draftsman (and his consequent familiarity with the possibilities of working in black and white) and in his association with not only the Abstract Expressionists but also the young New York photographers. Robert Frank and, in particular, Aaron Siskind, were

producing black-and-white images with an energized simplicity that was similar to Kline's abstractions.

Despite the apparent conflict between Kline's early and late work (the former would appear to be the result of a studied process and the latter conveys an immediacy and spontaneity), Philip Guston once recalled that Kline would in fact spend days or weeks reworking the edge of a stroke to give the impression that it had been painted with intensity and verve. Kline's painting style had more in common with Clyfford Still's careful application of craggy swathes of paint than the rhythmic dripping of Jackson Pollock.

In *Vawdavitch* (1955) and other works from this period, Kline was careful not to suggest a figure/ground relationship between black image and white field. He remarked on this issue, "I paint the white as well as the black, and the white is

just as important." Kline similarly denied the calligraphic quality of his expressive strokes, which he differentiated from both signs and symbols.

Art historian David Amfam has suggested that Kline's abstractions, like the work of the photographers Frank and Siskind, capture the spirit of 1950s New York. Jack Kerouac and the Beat poets, jazz, popular culture, and experimental film, all superimposed on the dramatic architecture of the city, stimulated a departure from the angst-ridden Abstract Expressionists and a move toward the vernacular. Kline's work offered an alternative to the symbolic sublime and one that was welcomed by a younger generation of artists such as Cy Twombly, Robert Rauschenberg, Brice Marden, and, in particular, Mark di Suvero, whose sculpture at times resembles a Kline in three dimensions. JM

Vawdavitch

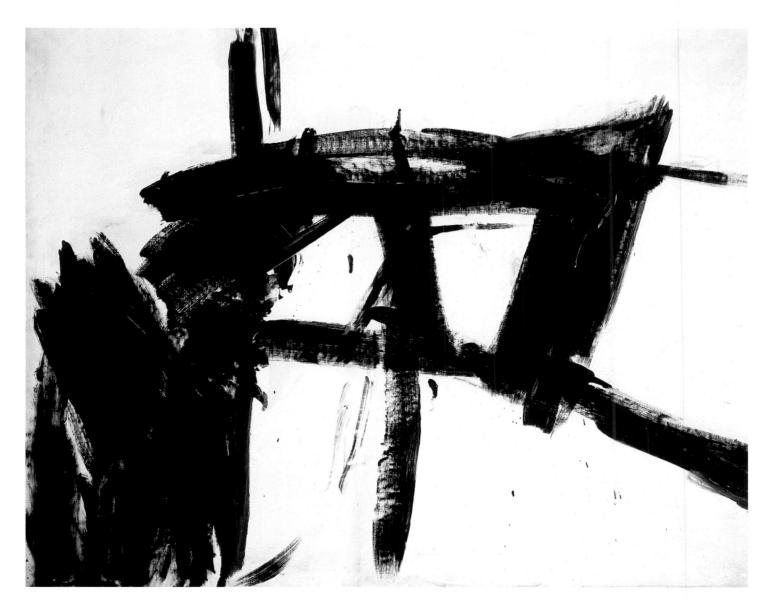

1955
Oil on canvas
62 $^1/_4$ x 80 $^{11}/_{16}$ in. (158 x 204.7 cm)
Gift of Claire B. Zeisler
(76.39)

JEFF KOONS

•

American, born 1955

Marketing is the central theme for Jeff Koons. He rose to prominence in the 1980s, when America's preoccupation with consumption was the subject of intense media interest. Koons continues to view marketing as an all-encompassing communication system in American culture, through which our most vital myths, fetishes, taboos, social differences, and even existential conditions are conveyed.

Like the Pop artists, Koons uses familiar brand-name products or common objects, as in the case of *Three Ball Total Equilibrium Tank* (1985). Following Minimalism, the objects are usually manufactured in series. For example, there are several versions of the basketball tanks, some with one or two balls, some only half-filled with water. Seriality enables Koons to evoke industry. Moreover, the process he went through to construct the tanks allowed him to emulate business practice by playing

the role of entrepreneurial inventor. Koons is reported to have consulted over fifty physicists to determine how to make the basketballs float midway in the tanks.

Serial production has also impacted Koons's notorious marketing strategies. This includes exhibiting the same show simultaneously in several locations, thereby creating media events that mimic business practices, similar to the way a designer unleashes a line of products to many stores at the start of a season. When the basketball tanks were first exhibited in 1985, the show *Equilibrium* appeared simultaneously at International With Monument Gallery in New York and Feature in Chicago. Since 1985 Koons has increased his involvement with the publicity of his work. When he himself became a celebrity, in 1986, he began cultivating his persona as part of his art. Acting as a combination of all-American super-salesman and evangelistic con man, he

grew to rival the master of publicity art, Andy Warhol.

Although Koons the salesman has heartily endorsed everything about the media and consumer culture, his work is more complicated. Koons the artist often exposes contradictions at the heart of mainstream culture. In this work, for example, Koons examined myths of upward mobility. The Spaulding basketballs symbolize people whose interests are tied to the game. When the tank was first exhibited, Koons hung framed Nike advertisements showing famous African-American basketball players, thus making unmistakable his reference to those legendary exceptions to the rule of unachievable dreams. Even the status of these celebrities is fragile. Like fish in a fish tank, players thrive in a specialized environment, such as the sports industry, where they are protected but dependent. Koons has asserted that the tanks connote

"security" and "support"; they are "womblike" and the water is "amniotic fluid." Yet security and survival are precisely what is unstable here. Although the basketballs' defiance of gravity suggests defiance of normal limitations, the constricting, coffinlike enclosure of the tank speaks of limits.

Koons's play on dualisms extended throughout the *Equilibrium* exhibition: the tanks were accompanied by bronzed flotation equipment—a lifeboat (also in the MCA collection), a life vest with an oxygen tank, diving goggles, and a snorkel—items that, if taken into a real body of water, would sink, taking their users down with them.

AP

1985
Glass, iron, sodium-chloride reagent, and basketballs
60 1/2 x 48 3/4 x 13 1/4 in. (153.7 x 123.8 x 33.7 cm)
Gerald S. Elliott Collection
(95.55)

SOL LEWITT

•

American, born 1928

Sol LeWitt is a systematic artist; he creates a set of rules for a work and follows them to their conclusion. Many of these rules appear to deny expression and emotional content in the work, particularly if the material that LeWitt uses has a classical geometric component—cubes, squares, triangles, and circles. He is able, however, to create an almost mystical expressivity with minimal means, resulting in art of great sensuous beauty.

Although born in 1928, in the generation of Jasper Johns and Robert Rauschenberg, Sol LeWitt achieved prominence only in the early 1970s with a group of artists such as Carl Andre and Robert Mangold. They retained the material quality of their works (when Conceptual artists, for example, were making them with almost no physical presence). LeWitt's *Sentences on Conceptual Art*, published in 1969, stressed the importance of reduced means, reduced emotional content, and a careful response to the gallery space—the white box—for which much of the work was made. The art demanded a return to the Constructivist principles of an earlier part of the century and an unprecedented complicity between artist and curator in its presentation. LeWitt was able in subtle and simple ways to convert the market to accept new forms and rules for the purchase of avant-garde art.

LeWitt's own work developed as sculptures (often in series), drawings and prints, and perhaps most significantly, wall drawings. For a wall drawing LeWitt offers a written description, which becomes a certificate of ownership, and instructions on the production of the work. It may be exhibited in more than one place and does not need the artist to draw it. It usually must be scaled to fit the wall where it is drawn.

One-, Two-, Three-, and Four-part combinations of Vertical, Horizontal, and Diagonal Left and Right Bands of Color, 1993–94, a suite of gouaches purchased from the artist on its completion, is no less dramatic in scale, although its means are more conventional. LeWitt used stripes of equal thickness of gouache in diluted primary colors to fill the area of each of the sixty-four sheets. He established the components—vertical, horizontal, diagonal (left to right), diagonal (right to left)— in the first group of four. In the second group (illustrated here), he divided the sheet in half and presented all the combinations of the pairs (vertical/horizontal, vertical/diagonal l/r, vertical/diagonal r/l, horizontal/diagonal l/r, and horizontal/diagonal r/l). In the third he showed all the three-part combinations and completed the work with all four-part combinations. The result is sixty-four sheets, whose complex generation is obvious when they are shown together. LeWitt's art demands not only an appreciation of the beauty of the completed work, but an understanding of the intellectual demands the work makes. Holding a mental image of the proposal and working it out conceptually is an important part of the process of looking at it. LeWitt has changed the way in which we are expected to understand a work of art. It is a change of profound importance.

RF

One-, Two-,Three-, and Four-part combinations of Vertical, Horizontal, and Diagonal Left and Right Bands of Color

1993–94
Gouache on paper
Set of sixty-four sheets, each
30 x 22 in. (76.2 x 55.9 cm)

Restricted gift of Alsdorf
Foundation, Lindy Bergman,
Ann and Bruce Bachmann,
Carol and Douglas Cohen,
Frances and Thomas Dittmer,
Gael Neeson and Stefan

Edlis, Jack and Sandra
Guthman, Anne and William J.
Hokin, Judith Neisser, Susan
and Lewis Manilow, Dr. Paul
and Dorie Sternberg, Howard
and Donna Stone, Lynn and

Allen Turner, Martin E.
Zimmerman. Mr. and Mrs.
Burton W. Kanter, Ralph and
Helyn Goldenberg, and Marcia
and Irving Stenn
(94.13.a-lll)

RENE MAGRITTE

•

Belgian, 1898–1967

René Magritte belongs to a select group of artists who can claim a successful merger of the everyday and the fantastic in their art. His visionary work has influenced artists such as Marcel Broodthaers, Robert Gober, and Allan McCollum, as well as many advertisements and popular movies. A painting such as *Les Merveilles de la nature (The Wonders of Nature)* (1953) illustrates fully Magritte's poetic sensibility. Here he has depicted two fish-headed lovers apparently joined in song. The painting betrays an affinity to fellow Surrealist Salvador Dali, yet conveys a greater sense of whimsy and humor than the more bizarre and sexually provocative works of Magritte's Catalonian contemporary.

Magritte, born in 1898, was the oldest of three sons of a minor industrialist in Lessines, Belgium. He studied at the Académie des Beaux-Arts in Brussels, served in the military, and in 1927 moved with his wife, Georgette, to Paris, where they became part of the Surrealist milieu. The Magrittes left Paris for Brussels in 1930 as a result of personal differences with André Breton. In Brussels, Magritte took a leading role among the Belgian Surrealists. He died in 1967.

The token mermaid form of the fish-tailed, human-torsoed being is reversed in *Les Merveilles de la nature*, making a creature of fantasy even more unreal. Despite their petrification in stone, the figures appear to be very much alive, with an uncannily human quality. *Les Merveilles de la nature* is exemplary of Magritte's use of the theme and appearance of petrification throughout the 1950s. The painting also contains visual elements found in earlier paintings, such as the ghost ship that blends with the waves on the horizon, which made its first appearance in *The Seducer* (1950), or the figures themselves, found in an earlier incarnation, *Collective Invention* (1935).

Magritte, like many of the Surrealists, was well acquainted with the prose poem *Les Chants de Maldoror* by the nineteenth-century French poet Isidore Ducasse, who worked under the pseudonym Comte de Lautréamont. Among the illustrations that Magritte created for a 1948 edition of Lautréamont's work was a depiction of a fish with human legs sitting on a rock by the sea with a small ship coursing the waves in the distance. This association may account for the confusion over the painting's title, once given as *The Lovers* in a 1964 exhibition in Little Rock, Arkansas, and for a long time known at the MCA as *Song of Love*. Magritte had informed Joseph and Jory Shapiro, the original owners of the work, that the title was *Le Chant d'amour*. Yet, when asked by his friend Harry Torczyner at the time of his retrospective at The Museum of Modern Art in 1965, Magritte said that he could not remember the title. Research for the recent catalogue raisonné of Magritte's work revealed the painting's actual title and the date of creation, proving that the painting had been in a mermaid theme exhibition and a solo exhibition at La Sirène in Brussels in 1953, thereby identifying the sole work unaccounted for from this period, *Les Merveilles de la nature*.

DM

1953
Oil on canvas
30 ¹/₂ x 38 ³/₈ in. (77.5 x 98.1 cm)
Gift of Joseph anc Jory Shapiro
(82.48)

BRICE MARDEN

•

American, born 1938

Providing Minimalism with perhaps its most poetic expressions, Brice Marden's abstract paintings of the 1970s are characterized by subtle juxtapositions of color built up to create an extraordinary surface. A maverick of sorts within the movement, Marden eschewed the use of industrial materials and the occupation of physical space that characterized the work of other Minimalists, opting for a much more human scale and medium. His work immediately recalls late-Modern Masters such as Ad Reinhardt and Barnett Newman, yet his concerns differ greatly from those of his predecessors; he rejects their worldly spirituality for a more subjective approach to the materials and process involved in conceiving and creating the art object.

In 1965 Marden began to mix wax with oil for a more physical, dense quality to the monochromatic fields that he had been painting since graduate school. He received his first one-person show at the Bykert Gallery in New York in 1966. His monochromatic paintings of this time located him squarely between Minimalists such as Donald Judd, whose work was similarly involved with distilling aesthetic expression to its most basic and essential forms, and Richard Serra and Bruce Nauman, who were investigating the "act" of making art in their post-Minimalist creations. Marden's works, however, using odd colors whose saturation in wax serves simultaneously to absorb and project light from their surface, induce a sense of meditative contemplation in the viewer.

Grove Group V (1976) developed out of a series of vertically joined diptychs and triptychs, each panel a single color, which Marden had begun making by 1968. Enamored of the Mediterranean climate, Marden made his first visit to Hydra in Greece in 1971; *The Grove Group*, begun in 1973, was inspired by a Greek olive grove. In *Grove Group V*, a light gray-blue rectangular field is flanked by gray-green fields of equal size and shape, yet of a slightly variant gradation in color. The absence of representational matter in the painting leaves the viewer to observe the interaction of the colors on the plane created by Marden's joining together the separate canvases. One might see a highly abstracted landscape in the presence of the blue field at the center of the painting.

Yet the dull materiality of the wax-laden color complicates any attempt at allegory. This delicate interplay of hues on a flat surface gives *Grove Group V* an insular and abstract quality that heightens its emblematic harmony.
DM

1976
Oil and wax on canvas
72 x 108 in. (182.9 x 274.3 cm)
Gerald S. Elliott Collection
(95.67)

MATTA (ROBERTO MATTA ECHAURREN)

•

French, born Chile, 1911

Matta, a member of the original Surrealist group founded in Paris in 1924 by André Breton, brought to this movement a magical sensibility often associated with South America. Originally trained as an architect in his native Chile, Matta relocated to Europe in the early 1930s; he worked in Le Corbusier's office in Paris and associated with many leading architects, artists, writers, and intellectuals of the day, including Walter Gropius, László Moholy-Nagy, Pablo Picasso, Marcel Duchamp, Gertrude Stein, André Breton, and Pablo Neruda. He arrived in New York in 1939, where he became part of the émigré community of Europeans fleeing World War II and played a major role in the genesis of the Abstract Expressionist movement through his brilliant intellect, charismatic personality, and mentoring of such younger figures as Arshile Gorky, William Baziotes, and Jackson Pollock.

Matta's paintings were at this time vaporous washes that formed amorphous shapes within tenuous lines; these "inscapes," as he referred to them, show his continuing association with fellow Surrealists Pavel Tchelitchew and Yves Tanguy. After travels in Mexico in the mid-1940s, his imagery became more concrete and colorful, with paint thickly applied in an expressionist manner. Many of Matta's most highly regarded works were created during this period before he returned to Paris in 1948. After being expelled from the Surrealist group, he moved to Rome, where his interest in magic and mysticism—brought forth in Mexico—was balanced by an interest in science that was newly cultivated by contacts with a younger generation. The works of this period, such as *Let's Phosphoresce by Intellection #1* (c. 1950), feature enigmatic linear forms, both organic and mechanistic, inhabiting a strange and uncertain space. In this work several entities—all with faces that seem part mask, part machine, part human—hover over a prone female figure. In Surrealist writings, Matta described environments that would cybernetically adapt themselves to an occupant, and provide "surfaces which he [the viewer] could fasten to himself exactly…carrying our organs in well-being or sorrow to their supreme degree of consciousness." This painting, as a "psychological morphology"—another term Matta used to describe his art—seems an illustration for this convergent world the artist described years earlier.

LW

c. 1950
Oil on canvas
58 x 69 ⁵/₈ in. (148.6 x 179.1 cm)
Gift of Mr. and Mrs. E.A. Bergman
(76.45)

BRUCE NAUMAN

•

American, born 1941

Since the mid-1960s Bruce Nauman has pursued ideas of language, body, and self-definition, through a witty, albeit relentless, assault on traditional notions of art-making. Throughout his thirty-year career, he has played with the identification of self. Relying on irony and a remorseless dramatization of human weakness, Nauman's art provokes an often prickly contemplation of self. Nauman has said that his work comes out of being frustrated by the human condition. The act of making art, in Nauman's hands, becomes a physical act of thinking, an act that insists upon the mental, and often physical, activity of the viewer.

Just out of graduate school, where he focused on making sculpture, Nauman began to experiment with photography, film, video, performance, sound, and neon. He also began to think of his own body as a plausible artistic medium and his simple activities in the studio as art.

Self-Portrait as a Fountain (1966–67) belongs to a series of photographs in which Nauman literally acted out verbal expressions. He used the analogy of the "artist as fountain" in several works, including an enormous pink mylar window screen inscribed with the words, "The True Artist Is an Amazing Luminous Fountain" (1966). No doubt Nauman's human fountains also punned Marcel Duchamp's infamous and hugely influential transformation of a urinal into *Fountain* (1917).

Nauman has frequently incorporated text—printed, spoken, or implied—to produce works that ultimately materialize from the disjunctive intersection of language and object-making, from language embodied by gesture and activity. He has used language, often in the form of neon signs, like he has used the body—as plastic material. His 1983 neon *Life, Death, Love, Hate,*

Pleasure, Pain wryly spells out the parameters of human nature in big, plain English. Life and death, love and hate, pleasure and pain flash alternately, in roman and italic type, in an endless circular dialogue. Nauman offers no answers, but instead leaves the viewer with infinite questions. Nauman has made numerous variations on this theme, including a closely related neon, *Human Nature/Life Death* (1983), which won the 1983 Chicago International Sculpture Purchase Prize.

Elliott's Stones (1989) was originally commissioned by the late collector Gerald S. Elliott whose 1994 bequest of more than one hundred works, including thirty-one Naumans, is the largest single gift in the MCA's history to date. *Elliott's Stones* consists of six carved granite stones, each inscribed with a slightly varied, two-word phrase: "above yourself," "after yourself," "before yourself," "behind yourself,"

"beneath yourself," "beside yourself." Nauman intended the installation of the stones to be variable. No matter what the arrangement of the stones, the viewer becomes the center of the piece. Each stone is read in relation to the reader's body. Text and space trade places; their boundaries blur. Language takes on spatial and temporal, sculptural dimensions. *Elliott's Stones* proposes a definition of space and thought in relation to the body and suggests measuring one's being through a kind of physical thought process. *Elliott's Stones* encourages us to think about the body in relation to where we are and to imagine the self connected to philosophical and spiritual ideas. He questions why we are, how we exist and create; he makes us think.

LB

Self-Portrait as a Fountain
(from the portfolio *Eleven Color
Photographs*)

1966–67/1970
Chromogenic color print
19 ¹¹/₁₆ x 23 ⁵/₈ in. (50 x 60 cm)
Edition: 8/8
Gerald S. Elliott Collection
(94.11.11)

BRUCE NAUMAN

•

Elliott's Stones

1989
Granite
Six stones, each approximately
3 3/4 x 39 7/8 x 25 5/8 in.
(9.5 x 101.3 x 65.1 cm)
Gerald S. Elliott Collection
(95.2.a-f)

1983
Neon
Dia. 70 ⁷/₈ in. (180 cm)
Gerald S. Elliott Collection
(95.74)

95

CLAES OLDENBURG

•

American, born Sweden 1929

Claes Oldenburg's fascination with the humorous and disruptive effects of gigantism—specifically, the relation between minor things and major formats—was not only shared by the other major figures in Pop Art (for example, Andy Warhol and Roy Lichtenstein), but had an esteemed history in the writings of two famous satirists. Jonathan Swift's *Gulliver's Travels*, written in the eighteenth century, and the early twentieth-century novel *Alice's Adventures in Wonderland*, written by Lewis Carroll, aimed to disrupt and defamiliarize our accustomed relationship to the world—and with that our accepted social hierarchies—by reversing the "natural" order of things.

Although Oldenburg's work may not reflect quite the same ambitions for cultural change as Swift and Carroll, it contains a savvy, but humorous, look at the advertising techniques and commodification of 1960s America.

Moreover, Oldenburg's sculpture infused contemporary art with kitsch and corporeal associations that provided a jolt of the "real" after the high seriousness of Abstract Expressionism's ethereal and universalist aspirations.

The history of Oldenburg's oversize sculptures can be traced back to the collection of debris and junk he collected from the streets of Manhattan's Lower East Side. These commonplace, pop-culture objects would appear in the "Happenings" and installations he orchestrated in the early 1960s and were later simulated in lumpy, sagging, painted plaster versions that were sold at Oldenburg's *Store* (1961–62) in Manhattan. The concept of the *Store*, like Warhol's "Factory," aptly captured the iconoclastic attitude of the Pop artists. It simultaneously pointed to the involvement of art in a market, and the status of the art object as a commodity, as well as deflating the uniqueness of

the art object by a process of mass production.

After the plaster objects came floppy canvas food and clothing sculptures that sat deflated but potentially alive, on the floor, without pedestals. A move to vinyl around 1962 allowed for more direct corporeal associations. The potential for color and the smoothness of the surface, as well as the sagging fall of the material, conjured up both the thrill of sexuality and the failings of the flesh. *Green Beans* (1964), for example, consists of eighteen "beans" sliding on top of each other in a variable heap.

Oldenburg grew up in Chicago. The child of the Swedish consul, he attended Yale University in New Haven, Connecticut, from 1946, and then returned to Chicago and enrolled at the School of the Art Institute in 1952. During the mid-1950s, while in Chicago, Oldenburg developed the habit of collecting street

junk and keeping an extensive journal of ideas and illustrations, pasting in unintentionally humorous advertisements from magazines.

During the mid-1960s, in an escalation of absurdity, Oldenburg introduced into his repertoire the "Proposed Colossal Monuments"— drawings of enormous versions of his object sculptures placed in prominent locations in metropolitan centers. One of the few actually completed proposals is the *Batcolumn*, (1977), in front of what is today the Harold Washington Social Security Center on Madison Street in Chicago.

JM

1964
Vinyl and painted Formica
Eighteen parts, each
2 x 11 3/4 x 5 in. (5.1 x 29.8 x 12.7 cm)
Gift of Anne
and William J. Hokin
(96.5)

ED PASCHKE

•

American, born 1939

The definitive Chicago artist for more than two decades now, Ed Paschke has captured the feel of the garish, urban landscape at the century's end. Displaying an early fascination with bizarre human subjects—tattooed ladies, beefy wrestlers, and circus freaks—Paschke has developed his own style of manipulation, fragmentation, and mutilation of the human body in his canvases. *Adria* (1976) is an excellent example, taking a distinguished member of the local art community, art critic and historian Dennis Adrian, and transforming him into a figure of fantasy. Situated between Paschke's more lurid pictures of the 1960s and the cool, neon-like abstractions of the 1980s and 1990s, *Adria* possesses the wild, Surrealist tendencies of the former and foretells the elegant, day-glo color schemes and the restrained formality of the latter period.

Pashcke was born in 1939 on the Northwest side of Chicago. He attended The School of The Art Institute of Chicago, receiving his BFA degree in 1961. After graduation he held a string of unusual jobs, including working as a psychiatric aide and selling spot illustrations to *Playboy* magazine (where twenty-eight of his illustrations have been published from 1962 through 1989). Drafted into the Army in 1962, Paschke spent two years illustrating weapons-training aids and pursuing AWOL soldiers in Louisiana. Following a brief trip to Europe, Paschke returned to Chicago and in 1965 took a job at the Wilding Studio with a team of draftsmen rendering a map to be used in training astronauts for the Apollo moon mission. Paschke then began work for Silvestri, a display company, painting a Piranesi-style scene on the temporary façade around the first-floor window of the Carson, Pirie, Scott and Company Department Store. By 1967 Paschke quit working to give himself time to paint, and on the GI Bill, he enrolled at the School of the Art Institute, receiving his MFA degree in 1970.

Paschke is regarded as one of the foremost "Imagists"—a name created by critic and historian Franz Schulze to define the punchy, Surrealistic, pop culture–informed, figurative art that emerged in Chicago from the middle of the 1960s to the early 1970s. Dennis Adrian, like Schulze, was an ardent supporter of Chicago painters, and Paschke's homage brings his likeness to the viewer on a heroic scale. The flamboyance of the oversized hat, the swinging padded appendages replacing his arms and hands, and the lush, oval-patterned backdrop offsets the rigid classical frontality of Adrian's "pose."

Adrian did not actually sit for the painting; Paschke painted the piece from a photographic model, and so the uncommissioned piece was quite a surprise for its subject. The painting was acquired by Susan and Lewis Manilow and was given to the MCA in 1988 in honor of Dennis Adrian.
DM

Adria

1976
Oil on canvas
96 1/8 x 74 in. (243.8 x 188 cm)
Gift of Susan anc Lewis Manilow in
honor of Dennis Adrian
(88.6)

ADRIAN PIPER

•

American, born 1948

Born and educated in New York, Adrian Piper studied fine art at the School of Visual Arts in New York, then received her PhD degree from Harvard University in 1981. While living in New York in the late 1960s, she began to devote her attention to politically motivated Conceptual Art, and came into contact with other artists, such as Vito Acconci and Hans Haacke, who were similarly concerned with producing multimedia, confrontational work. Conceptual Art values, or emphasizes, the idea or concept over execution, and Piper's performances, texts, and installations established her as one of the pioneers of this movement. The artist believes emphatically in the power of art to change people's attitudes, whether by confrontation, rational argument, or shock tactics—all of which she employs, with searing intensity, in her own work.

Motivated particularly by the US government's actions in Vietnam and the Kent State Massacre in 1970, Piper focused on some of America's most complicated, and ongoing, destructive legacies: racism and xenophobia. Although her work cannot be dismissed as simply autobiographical, her life experience as a light-skinned African-American woman (her own designation), and the racism she experienced from both black and white communities, has informed her art.

Piper's earliest Conceptual performances were a series of public guerrilla actions. These pieces, which she called *Catalysis*, involved drawing attention to herself by antisocial behavior or assuming a guise of exaggerated otherness. In one of the *Catalysis* performances, Piper traveled the New York transit system with a red towel partially stuffed into her mouth; on another she entered what is now the

Trump Hotel with Mickey Mouse helium balloons attached to her teeth, hair, and clothing. Her graphic work consists of her own text, or combinations of media imagery and text, through which she suggests the fears, fantasies, and xenophobic feelings that the white viewer might be having, but not voicing, when confronted with images of black people in the news.

The installation *Cornered* (1988) stages some of what Piper considers to be the white-liberal viewer's lingering, unspoken, racist assumptions. On encountering the installation, the viewer is confronted by a video monitor playing a tape of Piper, dressed in pearls and sensible clothing, giving the news reporter-style with just her upper body showing, facing the audience head-on. The monitor is placed on a box and draped with funereal black cloth. Leaning against the box is an upturned table and in front of the table are

chairs. Above the video screen, on the wall, hang two birth certificates issued for Piper's father, also a light-skinned African-American, one of which categorizes him as white, the other, black. Piper begins her on-screen monologue with the statement, "I am black," and continues to reason out the various hostile reactions the audience may have to this assertion coming from a woman who appears to be white. The artist thus corners the viewer in a dialogue to which he or she might respond with an ideological reassessment concerning race, to be followed, perhaps, by political action.
JM

1988
Video installation with birth
certificates, videotape, monitor,
table, and ten chairs
Dimensions variable

Bernice and Kenneth
Newberger Fund
(90.4)

AD REINHARDT

•

American, 1913–1967

Although Ad Reinhardt had been producing nonobjective paintings since the 1940s, interest in his work was overshadowed first by the critically acclaimed Abstract Expressionists and subsequently by the Color Field painters. Reinhardt's commitment to a nonobjective geometric abstraction only received its due acclaim with the development of the similarly reduced pictorial elements and geometric forms of Donald Judd, Carl Andre, and Sol LeWitt's Minimalist sculpture in the 1960s. Reinhardt's work and writings provided a context and an inspiration for this younger generation's utterly unromantic and nonreferential abstraction, and created a historical link to the nonrepresentational art that had emerged from Europe in the second decade of the twentieth century.

Having struggled with the formal precepts of late Cubism, Reinhardt produced collages in the late 1930s that bore some resemblance to the work of Jean Hélion and Ferdinand Léger. Although he later railed against the romanticism that he detected in both Abstract Expressionist painting and Dada and Surrealism, during the early 1940s his work flirted with a more gestural, quasi-surreal quality. By the end of the decade, however, he had clearly committed himself to the unemotional geometric abstraction of Josef Albers and others.

During the 1950s Reinhardt worked to reduce his paintings to the least referential configuration. The works were untitled, to avoid the misinterpretation of a name, and unlike the utopian aims of such early geometric abstractionists as Kasimir Malevich and Piet Mondrian, Reinhardt did not intend his paintings to be reflective of a universal purity or harmony.

Rather, his end-of-the-road apocalyptic gesturing is reflected in his statement, "I'm just making the last paintings which anyone can make." These "ultimate paintings" were produced from 1960 on when Reinhardt established the format of the five-foot-square canvas symmetrically trisected by one horizontal and one vertical to create a cross shape. In fact the canvases are not black, but consist of extremely dark red, blue, and green, one color each for the ground and the two directional divisions.

These startling canvases, like *Abstract Painting* (1962), initially confound the impatient viewer who sees only a black canvas. Careful concentration, however, brings to view subtle color differences— in this case a black background with a blue vertical and a red horizontal. Reinhardt claims to have intended no formal, metaphorical, or religious significance by the cross

element; he simply wanted to create the most symmetrical configuration (one which had already been put to use by Malevich as early as 1913). Surprisingly similar in retrospect to Mark Rothko's work, Reinhardt's paintings concentrate on light. But whereas Rothko's canvases seem to be lit by a glow from within, Reinhardt's suggest a tangible gloom that emanates from the surface of the paint itself.

JM

1962
Oil on canvas
62 $^1/_4$ x 62 $^1/_4$ x 3 $^3/_4$ in. (157.5 x 157.5 x 9 cm)
Gift of William J. Hokin
(81.44)

MARK ROTHKO

•

American, born Russia, 1903–1970

Mark Rothko adamantly denied that his luminous, abstract, color-field paintings should be interpreted formally. The artist's statements, such as that made to his friend Seldon Rodman, in which he declared, "I'm not an abstractionist…I'm not interested in relationships of color or form or anything else…I'm interested only in expressing basic human emotions—tragedy, ecstasy, doom and so on," suggest that the only critical interpretation acceptable to the artist was a communion between viewer and painting that relied upon a nigh-universal transcendental experience. The Abstract Expressionists and their contemporary critics were driven by the desire to convey the transcendental and to create an art that expressed basic human emotions for an increasingly secular world.

Born in Dvinsk, Russia, in 1903, Rothko immigrated with his family to Portland, Oregon, in 1913. Rothko later moved to the East Coast. He studied at Yale University (1921–23) but never completed his degree, and then moved to New York, where he became involved in a series of socialist arts groups in the 1930s, such as the Artists Union and the American Artists Congress, during which time he worked on representational paintings. Like the work of many Abstract Expressionists, Rothko's early paintings from the 1940s reflect the influence of Surrealism and in particular the work of the Spanish artist Joan Miró. The Surrealistic biomorphic fantasies developed, in other artists' work, into the expressive gestural style of what the critic Harold Rosenberg, in 1952, called the "Action Painters." Rothko, however, eliminated forms from his work and concentrated on creating a luminosity within the scumbled surface of the paint, gradually developing the rectangle-based compositions for which he is now renowned.

The affinity of Rothko's work to spiritual and religious painting has been used to explain the impact of his canvases. Their size and the manner in which they are frequently displayed—apart from other artists' work, often in a room of their own—elicit a comparison to European altarpieces and devotional objects. The art historian Anna Chave has suggested that the format that Rothko settled on from around 1949—stacked rectangular fields of luminous color floating nebulously on a saturated canvas—could reflect Rothko's early interest in religious iconography. The rectangles could reflect specifically the horizontal composition of an entombment or adoration scene or perhaps a pietà (in which the seated Virgin supports the horizontal body of the dead Christ). However, it is the series of paintings that Rothko produced for the de Menil chapel in Houston in 1967 that firmly established the artist as a creator of iconic images.

Upon recovering from the serious illness he contracted after the completion of the chapel, Rothko began to paint smaller acrylic works on paper, only gradually working up to painting on canvas on a medium scale. The year before he took his life, 1969, was one of Rothko's most productive years. Among the works he produced was a group that explore the possibilities of black or very dark green or blue on a bright blue surface. These acrylic works on paper include *Untitled* (1969), which combines two black rectangles on a blue surface. The blue is so bright that it confuses the figure/ground relationship between the forms in a magical balancing act typical of Rothko's late work. A related piece, another *Untitled* (1969), is in the collection of the National Gallery of Art, Washington, DC.
JM

Untitled

1969
Acrylic on paper mounted on canvas
78 ¹/₂ x 58 ⁹/₁₅ in. (199.4 x 148.8 cm)
Gift of The American Art Foundation
(95.21)

RICHARD SERRA

•

American, born 1939

In the early 1960s Richard Serra was a leading proponent of "antiform," a movement developed by, among others, Robert Morris and Barry Le Va, in which the artists utilized untraditional, soft, and malleable materials such as latex, rubber, and felt. From this beginning, Serra's work developed toward greater and greater rigidity and tension through his use of lead and, later, steel. Although Serra's progression from light industrial material (rubber) to the heavy-industry associations of steel may appear to suggest a radical change in artistic direction, in fact the artist has stated that his work has consistently focused on certain essential issues in sculpture: balance, gravity, and the sculpture's spatial relationship to the human body.

Serra's titles, "Prop," "Strike," and "Casting," for example, immediately alert the viewer to the physical impact of his sculpture and the action by which it was created. Unlike his contemporaries Bruce Nauman and Eva Hesse (who were also associated with antiform), Serra never figuratively evokes the human body, yet the scale and capacity for movement that dominate his work are firmly oriented to the human figure.

In an attempt to move away from the reductive and static qualities that Serra perceived in some Minimalist sculpture, he produced a list of transitive verbs, which he later used to describe the untraditional and process-oriented sculpture he produced. The list that included "to roll," "to crease," "to fold," and "to drop" stimulated deceptively simple sculptures like *Splashing* (1968), a thrown lead piece, which literally consists of what resulted from the action of throwing or splashing molten lead on the floor and wall. *Prop* (1968) consists of two separate pieces, a cylindrical pole and a lead plate, which demonstrate the title of the piece in a breathtaking configuration. The pole actually holds the plate in place against the wall by nothing more than pressure and tension. The piece at once draws the viewer's attention to the material quality of the work and metaphorically suggests the necessity of such interdependency in life. *Prop* is one of close to one hundred "prop" pieces comprised of flat and rolled sheets of lead made around this time. All of them consist of unpolished, mass-produced, raw materials that have surprisingly tactile and reflective surfaces.

The weighty, silent balancing act of *Five Plate Pentagon* (1988) alerts the viewer to consider the consequences of a fatal shift in balance, a shift we simultaneously dread and desire. *Five Plate Pentagon* and *Another Look at a Corner* (1985) are later works in which Serra began to use cut steel. (Having worked in steel mills to put himself through college and graduate school, he studied at the University of California, Berkeley, and then at Yale University, Serra was familiar with the properties and potential of this material, which he continues to use to the present day.) Less malleable and more rigid, steel allowed Serra to construct different configurations and to dramatically increase the scale of his work. These later works are often startlingly simple, but the increase in size and weight radically heightens the drama and sense of potential danger.

JM

Prop

1968
Lead antimony
Overall installed: 86 $\frac{1}{4}$ x 60 x 57 in.
(218.7 x 152.4 x 148.8 cm)
Gift of Mrs. Robert B. Mayer
(78.44.a-b)

CINDY SHERMAN

•

American, born 1954

Since the early 1980s Cindy Sherman has been recognized as one of the leading contemporary artists to show new possibilities in photography. Her work demonstrates that photography, formerly ghettoized as a subcategory of art, is worthy of the art historical significance traditionally accorded to painting. To accomplish this, Sherman rejected two dominant tendencies in the use of photography: First, she opposed Conceptual Art's use of photographs as documentary adjuncts to ideas or events and instead made the photograph the principal object of importance. Indeed the vivid physicality of her images—exaggerated by Sherman's tendency after 1980 to work in large scale—is key to their dramatic power. Second, Sherman rejected the tradition of camera-centered technical virtuosity that is based on manipulations of camera settings and the development of film. Sherman does not strive for formal stunts.

Instead, she focuses her manipulations on the process of staging a scenario. As in *Untitled #137* (1984), her disguises of costume and make-up, and use of props, lighting, and acting leave no descriptive detail unaccounted for. Sherman's artistic process is most like that of a film director creating a set. Not surprisingly, the artist has often cited film as a chief source of inspiration. In her work, however, Sherman plays every role: actress, photographer, make-up artist, prop person, director, etc.

In part because Sherman has used herself as a model in most of her photographs, and therefore has been constantly involved in masquerade, she has become for many art critics exemplary of the contemporary concerns of feminism and Post-modernism. Her work has dovetailed with feminists' study of images of women in popular media. Sherman's role-playing has also inspired discussion about how female subjectivity is constituted. For some, Sherman's character changes illustrate the schizophrenia of our Postmodern era. Her work, however, is not didactic, and neither is the artist. She prefers to leave interpretation open, refraining in interviews and statements from using specialized jargon or specifying the meaning of her work.

Certainly the identification of social types and scenarios is one of Sherman's dominant concerns. From the earliest series for which she became known, the "film-stills" of 1977–80, to her most recent, Surrealist-inspired experiments with the grotesque, uncanny, and other-worldly, Sherman has compelled her viewers to ask of each photograph, "Who or what is this?" Her work has ranged from portrayals of recognizable social stereotypes, as in her early film-stills, to presentations of disturbingly alien beings and circumstances. *Untitled #137* represents the point in her career when Sherman began to explore the dark realm of grotesquerie and madness. This particular image is made compelling by Sherman's crafty combination of contradictory clues: The civilized is juxtaposed with the taboo. The lovely, clean red sweater looks inconsistent with the woman's dirty appearance. The horror of the—blood-soiled?—hands contradicts the demureness of her downcast eyes. The signs of lowliness are in tension with the figure's classically dignified stature, which evokes images of a Renaissance Madonna.

AP

Untitled #137

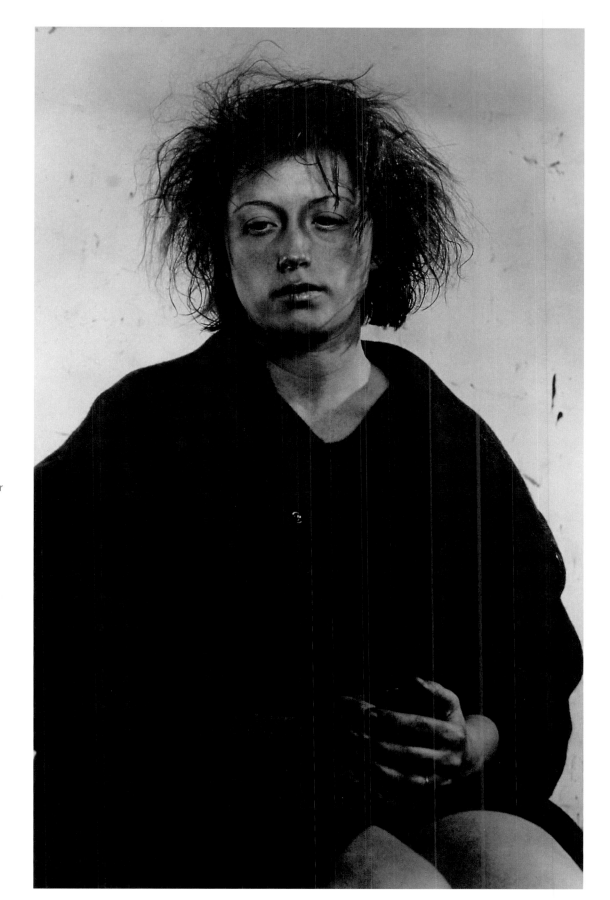

1984
Chromogenic color
print
70 1/2 x 47 3/4 in
(179.1 x 121.3 cm)
Ecition: 2/5
Gerald S. Elliott
Ccllection
(95.98)

LORNA SIMPSON

•

American, born 1960

Lorna Simpson's textual/photographic work eloquently questions stereotypical images of women, specifically of black women, by simultaneously revealing and resisting the dominant representations of gender and race. Like her slightly senior colleagues Barbara Kruger and Cindy Sherman, Simpson presents the female "object" as a complex subject by revealing how language and image insidiously can work together to create degrading stereotypes. Simpson uses a poetical and yet critical language in combination with images of black women and men to perform a series of interrogations, accusations, and pleas that both complicate and inform the issues of gender and race relations. Simpson's work is characterized by a somber, minimal aesthetic which requires concentrated attention in order to unravel the connections and contradictions between the verbal and pictorial elements. Like that of other politically motivated African-

American and feminist artists, such as Adrian Piper, Simpson's work has been informed by recent cultural criticism and the politically active role this discipline aspires to.

Simpson, who was born in Brooklyn and now lives and works in New York, received her BFA from the School of Visual Arts in 1982 and her MFA from the University of California, San Diego, in 1985. Typically, her text and photographic installations represent a generic "black woman," her face and its distinguishing characteristics hidden—variously cut off, turned away or masked—in order to suggest general rather than individual identity. Attention is not drawn to the figure's gender—posture and frequently clothing are subtly androgynous—and the text or words that accompany the images refer to racial or gender assumptions in a stylistic manner that could be called political poetry.

Simpson is clearly aware of nineteenth-century documentary photography in which black people, often slaves, members of other minority groups, and criminals were recorded for putatively scientific and anthropological reasons. Like the similarly objective and serial documentary work of the contemporary German photographers Bernd and Hilla Becher and their former student Thomas Struth, Simpson's ambiguous generic types deny the possibility of making accurate generalizations, let alone scientific observations, based on appearance, clothing, body language, skin color, or hair type.

Bio (1992) consists of eighteen Polaroid prints (nine plastic plaques) which are positioned in three horizontal rows. The central row is occupied by images of a woman dressed in a man's suit and shown in various "masculine" poses. The bottom row is a series of men's shoes, and along

the top are images of shoe boxes accompanied by text. The text refers (obliquely) to biological or physical suffering (panel three, for example, reads, "bled to death outside hospital 60 years ago"), and to the signs of difference contained within the black body which come under the punitive gaze of racism (panel four reads, "tendency to keloid"). The entire grid structure is united by the last three engraved plaques, which read "biopsy," "biology," and "biography." These three words bring to mind a powerful and disturbing concoction of pain (which is also suggested by the blood red that suffuses all the images), the physical attributes of difference, and the lack of a documented history from which a dispossessed people suffers.
JM

Bio

1992
Color Polaroids and plastic
plaques
Overall: 98 x 162 in.
(248.9 x 411.5 cm)

Gift of Maremont Corporation
by exchange; purchased
through funds provided by
AT&T NEW ART/NEW VISIONS
(92.90.a-u)

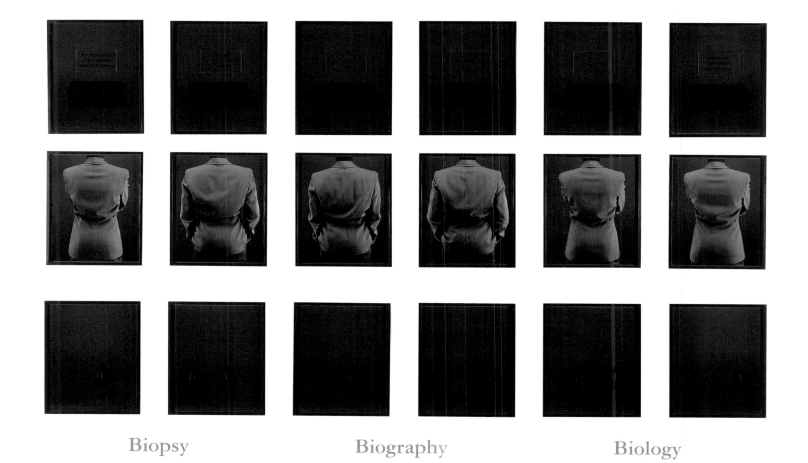

Biopsy Biography Biology

ROBERT SMITHSON

•

American, 1938–1973

Perhaps the premier Earth artist, Robert Smithson was extraordinarily productive during his short eight-year career. He created his major work, *Spiral Jetty*, in 1970, bringing together in one monumental form every aspect of his practice—earthwork, theory, and film. (Smithson's film *Spiral Jetty* is in the MCA collection.) At the time of his accidental death while working in 1973, Smithson had become internationally renowned for innovative projects that took art-making outdoors and brought the principles and material of nature indoors into the spaces of galleries and museums. Smithson's art challenged the very nature of the material, site, and temporality of art. His accomplishment has grown even larger due to the continuing influence of his numerous writings.

Smithson began to make sculpture in 1964, demonstrating a strong affinity for the principles of Minimalism. While formally linked to the sculptures of Donald Judd, Tony Smith, and Sol LeWitt, early works such as the MCA's *Mirror Stratum* (1966) distort and complicate the viewing experience. Squares of mirrors stacked in order of decreasing size suggest a constant shift between structure and illusion, between the solid geometry of the sculptural form and the ceaseless variation of the mirrors' changing reflections.

In late 1966 Smithson began to make regular excursions to various quarries and industrial sites in New Jersey, with such artist friends as Dan Graham, Carl Andre, Michael Heizer, Claes Oldenburg, Richard Long, and Sol LeWitt. He photographed the sites, collected materials, wrote about the excursions and sites, and began to make works

that incorporated the artifacts from his trips. His 1968 series of *Nonsites* consist of materials gathered from several sites, usually rocks or minerals, that he then regrouped in geometric containers and displayed, often with corresponding aerial photographs or maps of the original site. The process involved transferring materials from a site of origin to a site of exhibition.

A Nonsite (Franklin, New Jersey) (1968), one of the earliest *Nonsites* and the first Smithson to enter the MCA collection, is composed of five shallow wooden trapezoidal bins of decreasing size arranged on the floor. Each bin is filled with limestone rock collected from a quarry in Franklin, near Smithson's birthplace. On the wall hangs an aerial photograph of the site, which is segmented to correspond in shape and number to the bins. The formats of the bins and photographs mirror one another. Like his

strata of mirrors, Smithson's *Nonsite* creates an endless dialogue between structure and illusion, between origin and point of destination. Smithson was able to link origin with execution in a fashion of Conceptual collage, a compression of distinct worlds, information, and time, linking object-making with concept and the process of thought. The *Nonsites* allowed Smithson to extend his ideas and work to the outside world, and to make that world a participant in the spaces of the studio and the gallery.

LB

A Nonsite (Franklin, New Jersey)

1968
Painted wooden bins,
limestone, photographs, and
typescript on paper with
graphite and transfer letters,
mounted on mat board

Bins installed 16 $^1/_2$ x 82 $^1/_4$
x 103 in. (41.9 x 208.9 x 261.1 cm)
Board 40 $^1/_{16}$ x 30 $^1/_{16}$ in.
(101.8 x 76.4 cm)
Gift of Susan and Lewis Manilow
(79.2.a-g)

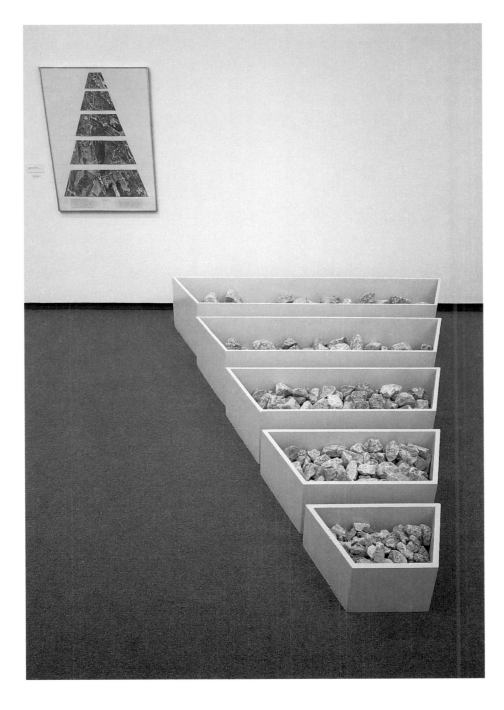

THOMAS STRUTH

•

German, born 1954

The German photographer Thomas Struth focuses in his work on the complexity of the act of looking. All three subjects in his Conceptual photography—urban landscapes, portraits, and museum interiors—are consistently used in an investigation of what it means to see, to observe, to gaze.

The urban landscapes, taken in Europe, the United States, and Asia, which Struth has called *Unbewußte Orte* (Unconscious Places) are relatively small, black-and-white architectural views that recall both the objective documentary photography of the artist's teachers, Bernd and Hilla Becher, and the unpopulated street scenes of the turn-of-the-century French photographer Eugène Atget. Struth characteristically chooses areas of a city that tourists are likely to visit only by mistake. The MCA's *Via Medina, Naples* (1988), for example, displays none of the architectural perfection typical of a postcard image, but concentrates instead on the disparate and often conflicting signs of an urban periphery. The aim is neither to romanticize the derelict nor to "educate" the socially unaware, but rather to elicit a more complicated reading through a patient examination of the image.

Struth's portraits are always of individuals and families he has come to know well, taken in surroundings that the participants themselves choose. Inhabitants of the desolate city areas he photographs, his subjects are uniformly middle-class, and the viewer's attention is focused on the small but noticeable cultural differences between the almost-same. In the MCA's *The Shimada Family, Yamaguchi 1986* (1988), in which the domestic group chose to be photographed in a Japanese garden, the family faces the camera, extremely self-conscious of their status as objects of the photographer's gaze. Their relationships, clothing, and the choice of setting all demand analysis by the viewer. Ultimately, however, the photograph frustrates by its refusal to disclose the (fictitious) "real" personalities, and calls into question the potential voyeurism of the art public.

Struth's examination of the act of looking reaches an apex with his photographs of visitors in museum galleries. He contrives a ricocheting sequence: the photographer watches the public looking at paintings in a museum; we the viewers see the photographer's view of the spectators looking at art, and thereby are made aware of our own action of looking at art in a gallery. *Kunsthistorisches Museum I, Vienna* (1989–90) is a striking example of Struth's remarkably subtle, complex, and often extraordinarily beautiful photographs. Concerned here again with the construction or "building" of images, in this series Struth drew attention to the history of compositional structures in art. Arranged in pairs, groups, and individually, the figures reflect the compositional structures of the surrounding Rubens paintings.

Kunsthistorisches Museum I, Vienna demonstrates both the reality and the artificiality of looking at art. Although clearly conscious of the comparisons that can be made between the leisure activities of visiting shopping malls and sports arenas, as well as museums, Struth is not out to condemn this—predominantly bourgeois—experience. Rather, avoiding the obvious, accusatory stance, Struth focuses attention on the long tradition of looking at art, with all its inherent sociological implications, on the museum experience, and even encourages us to feel the physical discomfort, or excitement, of sharing such an experience with strangers.

JM

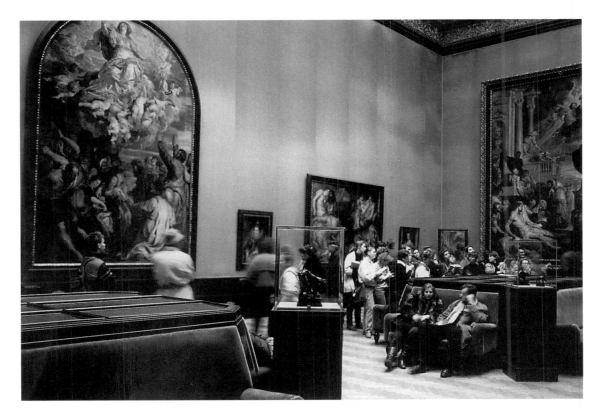

1989–90
Chromogenic color print
72 x 94 in. (182.9 x 238.8 cm)
Edition: 3/10
Gift of William J. Hokin, The Dave Hokin Foundation
(93.24)

ANDY WARHOL

•

American, 1928–1987

In his paintings, sculptures, drawings, films, and, most memorably, his silkscreens, Andy Warhol documented the products and by-products of 1960s America, especially its movie stars, commercial packaging, and the subjects of the new mass media. Although Warhol himself might have teasingly suggested that he was an uncritical receptacle of the images and signs of contemporary mass culture, his work hovers ambiguously between a celebration and a critique of American values.

Warhol's photo-silkscreen prints can be divided into thematic groups, including the packaging images (Campbell's soup and the Brillo boxes); film and media stars; and the "disaster series," which documents particularly American forms of death such as car crashes and the electric chair. The silkscreening process provided a technique of mass production that appealed to Warhol because

of its ability to undermine the uniqueness and originality of the artwork, but nevertheless produced slightly varied prints. Photo-silkscreen printing allowed for the least involvement of the artist after the initial image had been devised and, accordingly, in 1963, Warhol infamously stated, "I think that somebody should be able to do all my paintings for me." Although he delegated some of the printing to studio assistants in the "Factory" (his New York studio), and despite his spectacular comments to the media, he largely retained control over most if not all of his artistic production.

Warhol's silkscreens typically contain repeated serial images on one or abutting canvases. In reference to this use of film-reel–like repetition, Warhol stated, "the more you look at the exact same thing, the more the meaning goes away and the better and emptier you feel." As with all Warhol's

statements, however, the opposite is also true. The overreproduction alerts the viewer to the original source of this visual overkill— namely, the mass media— and its corruption of tragedy for the sake of sensation.

Like the "disaster series," Warhol's images of movie stars fall into the long tradition of the "vanitas" theme (in which the viewer is reminded of his or her own mortality). Warhol produced numerous versions of his prints of both Jackie Onassis (in her various roles as widow, mother, First Lady, and socialite) and Elizabeth Taylor (a brutal record of her turbulent career and physical decline). In fact, the stars chosen by Warhol were generally dead, either literally, at the box office, or, as in the case of Troy Donahue, B-movie actors who never achieved lasting fame. In *Troy Diptych* (1962), Warhol repeated the same saccharine image over two abutting screens,

one in filmic color and the other in newspaper print black and white. Presumably the oval-shaped photograph that is signed in the corner was taken from a fan-club handout. Through repetition, Warhol revealed Donahue's slick smile and perfect helmet of blond hair to be the vacant, simultaneously tragic and laughable product of a fickle Hollywood culture.

Details are surprisingly revealing in Warhol's work. The images in *Troy Diptych* are not identically reproduced: some are "carelessly" overinked to the point of obliterating Donahue's face; there is an uncomfortable blank area at the bottom of the canvas; and an inexplicable omission of three images disrupts the seamlessness of the mechanistic reproduction and directs the viewer to a more somber and unsettling reading of the painting.

JM

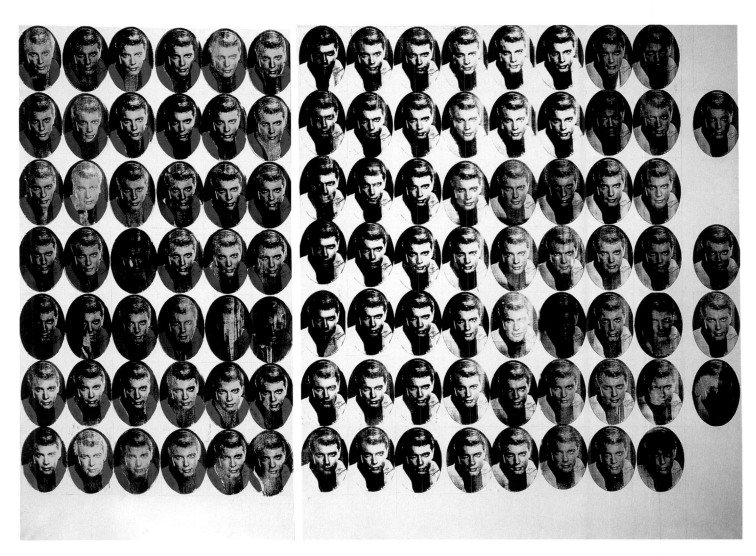

1962

Silkscreen ink on synthetic po ymer paint on canvas

Overall: 81 x 10 $^3/_4$ in. (205.7 x 271.1 cm)

Gift of Mrs. Robert B. Mayer

(84.1.a–b)

H.C. WESTERMANN

•

American, 1922–1981

H. C. Westermann has been associated with a number of twentieth-century art movements, from Surrealism to Chicago's first generation of postwar artists, the so-called "Monster Roster." Yet this artist's highly individual approach, together with his aversion to art theory, disavows his inclusion in any one category. Although much of his work draws upon and refers to personal experience, Westermann ultimately was concerned with universal themes of the unpredictability and danger of human existence and the absurdities of modern life—including the art world. The harshness of this often pessimistic view is mitigated by the subtle humor Westermann often infused into his work.

After serving as a Marine gunner in the Pacific during World War II, Westermann enrolled in The School of The Art Institute of Chicago, only to interrupt his education to reenlist in the Marines to serve in Korea. Older than many of his fellow students and profoundly affected by the horrors he had witnessed during his military service (including the devastation in 1944 of the USS *Franklin*), Westermann went his own way. After making his first sale to the great architect Mies van der Rohe, however, he began to exhibit regularly in Chicago and became associated with the Chicago School of figurative art.

Mad House (1958), donated to the MCA by the widely known collector of Surrealism Joseph Randall Shapiro, another early supporter of the artist, is a major work in Westermann's oeuvre and one of a number of pieces utilizing the theme of the house. Conceived and constructed while Westermann was residing in Chicago during the painful period between his first and second marriages, *Mad House* is an allegory on sexual frustration. It speaks hauntingly of the rejection, fear, insecurity, and even hatred that can come with the dissolution of a relationship. A particularly elaborate example of Westermann's consumate woodworking skills, the work is carefully fitted together from strips of fir and fastened with dozens of screws; punctured with various trapdoors, oddly placed windows, and assorted openings framed with stylized body parts; and incised with various inscriptions. Its overall form is reminiscent of a one-room schoolhouse, and it is surely no accident that Westermann transformed this symbol of childish innocence and nostalgia into a house of adult emotional horrors.

Mad House was the first sculpture by Westermann to enter the MCA collection, which now has extensive holdings of both the artist's sculpture and works on paper, including numerous illustrated letters to friends. While Westermann left Chicago in 1961 and received a great deal of national and international attention during his lifetime, he is often held up as a prototypical Chicago artist for his refusal to follow artistic fashion, for the affinity of his work to intuitive art, and for the deeply felt humanism that inspired his work.

LW

1958
Douglas fir, metal, glass,
and enamel
69 ⁵/₈ x 23 ³/₄ x 25 ³/₁₆ in.
(176.8 x 60.3 x 64 cm)
Gift of Joseph and Jory
Shapiro
(78.5)

Board of Trustees

Architecture and Building

Chicago Contemporary Campaign Committee

Architect
Josef Paul Kleihues
Berlin

Design Engineer
Ove Arup & Partners
London, Los Angeles,
New York

Associate Architect and Engineer
A. Epstein & Sons International
Chicago

Project Manager
Schal Bovis, Inc.
Chicago

General Contractor
W.E. O'Neil Construction Company
Chicago

Building and Design Review Committee
J. Paul Beitler
Chair
Edward F. Anixter
Richard H. Cooper
Gerald S. Elliott
Helyn D. Goldenberg
Marshall M. Holleb
John C. Kern
Lewis Manilow
Mrs. Robert B. Mayer
Albert A. Robin
Dr. Paul Sternberg
Jerome H. Stone
James R. Thompson
Allen M. Turner
John Vinci

Staff
Kevin E. Consey
Amy Corle
Nancy Dedakis
Mary E. Ittelson
Richard Tellinghuisen
Janet Wolski

Architect Selection Committee
Allen M. Turner
Chair
Mrs. Edwin A. Bergman
Kevin E. Consey
Mrs. Thomas H. Dittmer
Joan W. Harris
Ada Louise Huxtable
Bill Lacy
Robert N. Mayer
Paul W. Oliver-Hoffmann
Jerome H. Stone
Gene Summers
Richard Tellinghuisen

Campaign Leadership
Mayor and Mrs. Richard M. Daley
Honorary Chairs
Jerome H. Stone
Campaign Chair
Mrs. Thomas H. Dittmer
Chair, Major Gifts
King Harris
Chair, Corporate Gifts
Donna A. Stone
Co-Chair, Special Gifts
Governor James R. Thompson
Co-Chair, Special Gifts
Mrs. Paul Sternberg
Chair, General Gifts

Edward F. Anixter
Meta S. Berger
Mrs. Edwin A. Bergman
John D. Cartland
Robert G. Donnelley
Stefan Edlis
Gerald S. Elliott
Jeffrey S. Fisher
Helyn D. Goldenberg
Jack Guthman
Allan and Norma Harris
Thomas C. Heagy
William J. Hokin
Marshall M. Holleb
Mrs. Ruth Horwich
John C. Kern
Richard A. Lenon
Lewis Manilow
Robert N. Mayer
David Meitus
Paul W. Oliver-Hoffmann
Donald A. Petkus
Penny Pritzker
Albert A. Robin
Joseph Randall Shapiro
Mrs. Leo S. Singer
Marjorie S. Susman
Allen M. Turner
Martin E. Zimmerman

Staff
Kevin E. Consey
Carolyn Stolper Friedman
Christopher Jabin
David R. Luckes

Women's Board

July 1989–June 1996

Neil Barrett*+
Julie Baskes
Meta S. Berger*
Robin Loewenberg Berger
Lindy Bergman+
Marie Krane Bergman
Lois Berry
Lillian Braude*+
Tere Romero Britton
RoJene Budwig
Edie Cloonan*
Leslie Douglass*+
Diane Drabkin
Darby Epstein
Helen Fadim*
Ann Wood Farmer
Suzette Flood
Lynn Foster
Laura De Ferrari Front
Diane Gershowitz
Helyn Goldenberg*+
Hope Perry Goldstein
Lillian N. Coldstine
Virginia Gordon
Myra Gotoff
Judy Greenwald
Nancy S. Gutfreund
Velma Hancock
Lynn Heizer
Rhona Hoffman+
Linda R. Hortick
Frances G. Horwich
Ruth Horwich+
Vicki Hovanessian
Jacqueline Jackson
Peggy Jacobs
Dona B. Jensen
Jacquelyn Jones-Lipton

Sally Meyers Kovleru◆
Margo Krupp
Pat Kubicek+
Marilyn Kushen
Lori LaRose
Bonnie Glazier Lipe
Jacqueline Lippitz
Margaret Lockett
Audrey Lubin
Judy Malkin
Kay McCarthy
Madeleine M. McMullan
Beverly M. Meyer
Lee Meyer
Maia Mullin
Ruth Nath+
Judy Neisser+
Barbara A. Noonan
Lisa Pritzker
Laurie N. Reinstein
Marian Reinwald
Eliza Hoogland Reynolds
Donatella Riback
Desiree Glapion Rogers
Ellen Rosenfels
Betsy Rosenfield+
Shelley Rosenstein
Ginger Russ
Pat Rymer
Alice Young Sabl
Hope Samuels*
Marlene Samuels
Betty Seid
Carol Selle*+
Janet Blutter Shiff
Joyce E. Skoog
Marjorie K. Staples
Laurel Stradford
Marcia Stenr

Ann Stepan*+
Bea Gray Steponate
Dorie Sternberg+
Patricia F. Sternberg
Donna A. Stone*+
Adrienne Smith Traisman
Dana Shepard Treister**
Susan Tynan
Margot Adler Wallace
Marlene S. Waller
Barbara Marquard Wanke

*Past President
**Current President
◆President Elect
+Honorary Members

Collectors Forum

Contemporary Art Circle

New Group

Affiliates

**North Shore Affiliate
Board
July 1989–June 1996**

Evelyn Aronson
Pam Beckman
Carole Bernstein
Harriet Bernstein
Abby Block
Jean Albano Broday
Doris Charak
Sheri Citterman
Dottie Currie
Holly Erlich**
Sandi Errant
Karyn Esterman
Jeanne Flaherty
Mary Franke
Margie Friedman
Maureen Glassberg*
Barbara Glazier
Muriel Goldberg
Karyn Graff
Kathy Harrison
Rachel Horwitch
Margot Langerman
Meryl Levenstein
Jacqueline Lippitz
Miriam Lyon
Judy Malkin
Joanie Marks
Dottie Melamed*
Audrey Miller
Sunnie Mitchell
Bernice Nordenberg
Jeanne Oelerich
Lorraine Paddor
Beverly Rapper
Ann Rosen
Joanne Scheff

Carol Schreiber
Darlene Schuff
Marilyn Spungin
Sandy Topel
Beverly Valfer
Joan Zavis
Gloria Zieve
*Past President
**Current President

**North Side Affiliate
Board
July 1989–June 1996**

Kathy Aronstam
Dorothy Berns
Amy Burdick*
Regina Ceisler
Felicia Cohen
Karen Cohler
Dale Davison
Gale Gordon Davison
Susan Dee
Andrea Fisher
Judy Freeman**
Terry Friedman
Gwen Golan
Janice Gordon
Susan Grant
Phyllis Hemphill
Cathy L. Hertzberg
Janice Hightower
David Hirschman
Marilyn Hollenbeak
Justine Jentes
Melissa J. Kahn
Linda Lehman
Maria Leone
Jimmy Dale Love
Debbie Match

Susan Menely
Gayle Mindes
Tom Morris
Harriet New Delman
Barbara Noonan
Linda Nordenberg
Lauren Peck
Susan Pollack
Jill Portman
Nancy Rawson
Marlene Rimland
Bennye Seide
Clare Seliger
Linda Jackson Sharp
Sherri Schenkler
Barbara Singer
Paulette Solow
Michelle Taufmann
Lisa Thaler
Susan Walker
Susan Welter
David Wilner
*Past President
**Current President

**South Side Affiliate
Board
July 1989–June 1996**

Frances Barge
Patricia Bohannon
Christine Browne
Alberta Bryant
Eleanor Caldwell*
Lillian Cole
Barbara Cordell
Naomi Driskell
Cheryl Figgers
Dorothy Fletcher
Velma Hancock

Imogene Holland
Marie Howard
Martine Hutsell
Julia Elaine Johnson**
Connie Jones
Charlette Lackner*
Ruby Love
Marian Nicholas*
Ethlyn Rice
Betty Sandifer
Hortense Shaeffer
Lois Simms
Shirley Sullivan
Dorothy Wacley
Jeanne Webster
Mary Garder Williams
*Past President
**Current President

**West and Far West
Suburban Affiliate
Board
July 1989–June 1996**

Lynn Abbie
Bobbie Adrian
Ann Bloomstrand
Eileen Broide
Sheila Bruns
Barbara Carlson
Sylvia Christmas
Betty Cleland*
Camille Cook
Myrel Cooke-Titra
Lorene Dodril
Joan Gabric*
Kathy Gabriel
Suzanne Garnier*
Kay Garvey
Sandy Ging

Sylvia Giura
Sharon Hardy
Jeri Hejduk**
Barbara Hilpp
Sharon Hoogendoorn
Barbara Marek
Anna Mathy**
Gayle McNulty
Nancy Moreton
Betty Nagy
Carol Napper
Elaine Nerenberg
Augustine Neuert
JoAnne Nisbett
Rose Ann Owen
Mimi Rose
Ileen Rubinstein
Muriel Schnierow
Terry Seward
Joan Talano*
Dee Tovarian
Toni Troyer
Betty Wiebking*
Martha Wiltsie
Lee Zara
Susan Zwick
*Past President
**Current President/
 Co-chair

Volunteer Guides

Steering Committee
July 1989–June 1996
Susan Barton
Joyce Black
Arlene Brandeis
Christine Browne
Rachel Burgess
Merle Carson
Betsy Cole
Renee Collins
Dottie Currie
Sue Ettlinger
Leah Ferrara
Geoff Fleet
Lillian Goldstine
Gayle Jacobs
Sheila James
Barbara Kite
Anne Koch*
Joel Loughman
Ruth Lekan*
Elaine Liff
Lorraine Lornzini
Susan Ludwig
Miriam Lyon*
Debbie Match
Magdalen Matthews
Molly Milligan
Faye Morganstern
Carol Nasaw-Hurvitz
Elaine Perlman
Judith Podmore
Janice Ryan
Jo Rosenfels

Andrea Sandler
Edith Shore
Phil Shorr
Penelope Steiner**
Adrienne Smith Traisman
Marsha Weis
Betty Wiebking
Barbara Van Dorf*
Beverly Yusim
*Past President
**Current President

Museum Staff

Part Time

Susan Abelson
Marke Adkins
Brian Agne
Karen Albrektsen
Amy Allison
Lionel Alonzo
Bethany Anderson
Laura Anderson
John Arndt
Rashda Arjmand
Cheryl Bachand
John Baitlon
Joyce Banks
Karen Barcellona
Laura Bauknecht
Anne Becka
Maurice Bennett
Jeanine Bernhart
Shelly Blaemire
Elizabeth Bodner
Erin Bolema
Suzanne Bojdak
Thomas Boyle
Kenneth Bradburd
Kathleen Brendal
Keith Bringe
Eve Brooks
Lisa Brosic
Zachary Brown
Theresa Buffo
Alexis Burson
Steven Carrelli
Clifford Carson
Erik Carson
Marcia Carter
Kenitra Childress
Mia Celano
Doreen Chevrie

Elke Claus
Paul Coffey
Antoinette Collier
Denise Cox
James Davis
Jan Dean
Gary Deckard
Catherine Doll
Trang Donovan
Renee Dryg
Thomas Edgcomb
Alexander Eiserloh
Nicholas Eliopolus
Anthony Elms
Kevin Epperson
Andrew Ericson
Jayme Fantl
Robin Faulkner
Jon Fjortoft
Cathleen Flynn
Brenda Fudell
Emily Gage
Uganda Gaines
Joseph Garcia
Linda Gelfman
Kate Glazer
Anjali Grant
William Green
Eric Gude
Roberto Gutierrez
Stephen Halvorsen
Jessica Hann
Chris Hanson
Kathleen Hartman
Christopher Harvey
Elizabeth Haude
Deborah Haugh
Barbara Heilig
Sara Hohn

Esther Honson
Michael Hopkins
Douglas Hoppe
Stephanie Howard
Erin Hurban
Heather Ireland
Wendy Jacobs
Antoinette Johnson
Susan Jones
Amy Justen
Danielle Kelly
James Kendrick
Ronald Kirkwood
Brigitte Kouo
Frances Lacson
Brandon Lane
Jinaa Lane
Cara Langella
Michael Lash
Kim Larson
Mark Leonhart
Joanne Leopold
Yolanda Lewis
Travis Lomax
Brian Lynch
Samuel Mangen
Lorraine Mann
Brad Martin
Susan Matlon
Ronald Mayfield
Brigitte Maronde
Lori McAllister
Kevin McCarthy
Lindsey McCosh
Brennan McGaffey
Michael McGowan
Herbert Metzler
Lisa Michniuk
Paul Milholland

Dion Miller
Rebecca Morris
Naomi Muirhead
James Murray
Juliet Nations-Powell
Martin Ohlin
Jared Oberle
Randolph Olive
Samuel Pappas
Anthony Parker
Susan Petzold
Yolanda Philpot
James Prinz
Ted Purves
Jose Ramos
Toledo Ramos
Karen Reimer
Elizabeth Riggle
Bruce Riley
Brian Ritchard
Katie Rudigier
R.D. Sallie
Nevenka Samardzija
Martha Schlitt
Donna Schudel
Mindy Schwartz
Phil Seigert
Francesca Segal
John Seubert
Quentin Shaw
Vincent Shine
Scott Short
Carol Shuford
Thomas Sigmon
Jim Sikora
Hasie Sirisena
Cynthia Skanes
Maureen Sloan
Deborah Snead

Gilaine Spoto
James Stauber
Christopher Stewart
Quanetta Stewart
Laszlo Sulyok
Daniel Sutherland
Molly Swan
Cynthia Sy
Annette Tacconelli
Mark Takiguchi
Dina Tate
Christopher Taw
Latanya Taylor
Ronda Thorne
Elisabeth Treger
Alec Ulasevich
Darian Van
Anne Walker
Kate Walker
Keisha Watkins
Carol Wellinghoff
Katie Welty
Michael Whitney
Anthony Williams
Altis Williamson
Jeff Wonderland
Stephen Woods
Alphonso Young
Anna Yu
Joe Ziolkowski

Acknowledgments

Collective Vision: Creating a Contemporary Art Museum reflects the contributions of numerous individuals. The essayists, Franz Schulze and Eva M. Olson, have brought insightful perspectives to the new building and the history of the Museum of Contemporary Art, respectively. New and provocative discussions of works in the MCA Collection have been written by Lucinda Barnes, Curator of Collections; Staci Boris, Curatorial Assistant; Richard Francis, Chief Curator and James W. Alsdorf Curator of Contemporary Art; Domonic Molon, Research Assistant; Jessica Morgan, Curatorial Assistant; Alison Pearlman, Curatorial Intern; and Lynne Warren, Curator of Special Projects. Thanks to Sara Hahn, Curatorial Intern, who assisted with research.

Special thanks go to publication coordinator and editor Terry Ann R. Neff, whose tireless efforts are reflected throughout the book. Mary E. Ittelson, former Associate Director of the MCA, contributed significantly to the early stages of the project, and Lela Hersh, Manager, Collections and Exhibitions, contributed her extensive knowledge of both the Collection and museum history.

Special thanks also are due to the staff of the Design and Publications Department, who skillfully created this handsome volume, particularly the elegant design work of Donald Bergh, Director of Design and Publications, and the editorial skills of Amy Teschner, Associate Director of Publications. Their ideas and effort made this book possible. Thanks also to Anna Weaver, who titled the book and assisted with its production.

Joe Ziolkowski, James Prinz, Steve Hall of Hedrich Blessing, and Hélène Binet all contributed stunning photographs to these pages. Michael Thomas, Assistant Director of Public Relations, expertly gathered the historical photographs, and Juliet Nations-Powell, Photo Archivist, and Stacey Gengo, Photo Archives Intern, were invaluable in the overall management of reproductions.

Finally, for providing the inspiration for this project, I would like to thank the architect of the MCA's spectacular new building, Josef Paul Kleihues, and the numerous staff in his office, in particular Johannes Rath and Greg Sherlock in the Chicago office, who helped facilitate this book.

Kevin E. Consey